MW00806216

IMAGES
of America

MINING TOWNS
OF SOUTHERN
COLORADO

ON THE COVER: Workers pose with empty coal cars at the entrance to the Morley Mine in Las Animas County on its last day of operations in 1956. Through its 49-year history, the mine produced over 11 million tons of coal.

IMAGES
of America

MINING TOWNS
OF SOUTHERN
COLORADO

Staci Comden, Victoria Miller, and Sara Szakaly

ARCADIA
PUBLISHING

Copyright © 2013 by Staci Comden, Victoria Miller, and Sara Szakaly
ISBN 978-0-7385-9953-3

Published by Arcadia Publishing
Charleston, South Carolina

Printed in the United States of America

Library of Congress Control Number: 2013934754

For all general information, please contact Arcadia Publishing:
Telephone 843-853-2070
Fax 843-853-0044
E-mail sales@arcadiapublishing.com
For customer service and orders:
Toll-Free 1-888-313-2665

Visit us on the Internet at www.arcadiapublishing.com

CONTENTS

ACKNOWLEDGMENTS

We would like to thank everybody who helped make this book possible, beginning with the authors, Staci Comden, Victoria Miller, and Sara Szakaly, staff members of the Bessemer Historical Society whose daily work in the CF&I Archives and Steelworks Museum did not miss a beat while they spent long hours researching and selecting photographs. Thanks also go to digital media technician Bernadette Philipp for her scanning efficiency.

A long list of volunteers have given their time and talent throughout the past 10 years in our effort to reconstruct and preserve massive archives that could have been lost forever. We thank all of them for their help, and especially want to recognize Doris and Robert MacCannon, James Copeland, and Jim Brooks for their work on the CF&I mining collections; Tom Cummins, for his prolific data entry skills; and Prof. Jonathan Rees along with his wife, Laura, for their early work on preserving and arranging the voluminous photograph collection.

Thanks go to Jay Trask, the first archivist for the Bessemer Historical Society, for writing the introduction and for all of his early work to save the archival collections. Likewise, thanks go to former archivist Beverly Allen, all of the other assistants and technicians who aided in the effort to save the CF&I Archives, and to Dr. Lynn Burlbaw and his Texas A&M graduate students Yiwen Bi, Russel and Stephanie Evans, and Kristina Waller, for their help in exploring the end of an era.

Finally, thanks are extended to our always-helpful Arcadia acquisitions editor, Stacia Bannerman, and to the National Endowment for the Humanities for their generous support—especially our program officer, Joel Wurl, who so ably and kindly offers us direction in the development of our archives program.

All images, unless otherwise noted, are from the collections of the CF&I Archives at the Bessemer Historical Society in Pueblo, Colorado.

—Tim Hawkins
Archivist

INTRODUCTION

Southern Colorado's rich coalfields played an incredibly important role in the development and industrialization of the Rocky Mountain West. Both the companies instrumental in building the mines and mills and the individuals who lived and worked in the company towns dramatically shaped the culture and history of the region. The Colorado Fuel and Iron Company (CF&I) was the largest and most influential of these Colorado industrial empires. CF&I dates to 1872, when Gen. William Palmer and his colleagues in the Denver & Rio Grande Railroad (D&RG) wanted a local source for steel rails for their expanding narrow gauge railroad. Several subsidiary companies were created by the D&RG to secure the natural resources essential for the production of iron and steel. In 1880, they were consolidated into the Colorado Coal and Iron Company (CC&I). CC&I merged with its chief rival, the Colorado Fuel Company, in 1892, forming the Colorado Fuel and Iron Company. The newly consolidated company was controlled by John Osgood until 1903. When an expensive modernization campaign left CF&I drained of financial resources, John D. Rockefeller Sr. took advantage of its desperate need for capital and took control of the company. The Rockefellers remained the controlling interest in CF&I until the 1940s.

CF&I was the first vertically integrated steel mill west of the Mississippi River. It tried to control all of the necessary natural resources to produce steel and provide coal to domestic and industrial markets. Iron ore, limestone, dolomite, vast reserves of water, and coal are all integral to the production of steel. To satisfy these needs, the company owned and operated over 60 mines and quarries spread across Colorado, Utah, Oklahoma, Wyoming, and New Mexico. These holdings made the company the largest private landowner in Colorado. CF&I claimed some of the most important water rights along the Arkansas River, and created many reservoirs to quench the blast furnaces and feed coal washeries.

Since the natural resources that fueled the company were often located in areas without significant settlement or infrastructure, CF&I found it both advantageous and necessary to create new towns centered near coal deposits. The company provided all of the necessities for the workers, including housing, shopping and medical care. It took thousands of employees to operate such a massive company, and for many years, CF&I was Colorado's largest private employer. The promise of work in the mines and mills brought immigrants to the region from around the country and the globe. Italians, Croatians, Slovenians, Mexicans, Germans, Greeks, Japanese, Hispanic Americans, African Americans, and many more came to the CF&I coal camps and company towns. The workers brought their wives and children, creating incredibly diverse communities. The immigrant families lived in company houses, shopped at the Colorado Supply Company store, were educated in company-dominated schools, and were treated by company doctors.

In efforts to create a loyal, productive, and Americanized workforce, CF&I was a pioneer in corporate social engineering. The company created a Sociological Department in 1901, under the direction of its chief surgeon, Richard Corwin. The new department was charged with overseeing the "betterment of the workers." It sponsored lectures on hygiene, civics, politics,

home economics, history, and the dangers of communism. Classes in English, sewing, citizenship, electrician training, cooking, and many other topics were provided for workers and their families. Kindergartens were started in mining camps to help form good citizens, who would in turn become good company employees.

Despite the company's efforts, labor relations were tense and often exploded into conflict. CF&I was plagued by strikes during its early years, including an infamous coal strike (1913–1914) that resulted in the Ludlow Massacre, one of the most notorious incidents in American labor history. CF&I coal miners were striking for better pay, better working conditions, and recognition of the union. Many miners had been evicted from company-owned houses and were living in tent colonies. After weeks of tension, on April 20, 1914, Colorado state militiamen and company guards clashed with miners. When the battle finished, 16 people were dead and the Ludlow tent colony was burned to the ground. Over half the dead were children, who had suffocated in a pit under a burning tent. The violence escalated in Southern Colorado until Pres. Woodrow Wilson sent federal troops to quell the conflict.

The labor war shocked the nation and forced CF&I to alter some of its practices. John D. Rockefeller and Canadian labor relations expert W.L. MacKenzie King developed one of the first company-dominated trade unions to combat the negative publicity generated by Ludlow and to genuinely improve the working conditions. CF&I's Employee Representation Plan (ERP) became a model for many other corporations. Employees elected representatives, who would work with management to try to find solutions to grievances to avoid further labor disputes. The company unions were a major union avoidance strategy until outlawed by the National Labor Relations Act of 1935.

The ERP provided employees with a voice, but it was a voice heavily influenced by management. Workers wanted greater control and continued to support unionization throughout the ERP period. Labor disputes disrupted CF&I's operations in 1917, 1919, 1921–1922, and most importantly, 1927–1928. The Industrial Workers of the World (IWW), considered one of America's most radical labor organizations, called for a strike to protest the pending execution of Nicola Sacco and Bartolomeo Vanzetti. On April 8, 1927, most of CF&I's employees walked out of the mines. The strikers gained momentum and picketers spread across the Colorado coalfields. The strike fizzled by early 1928, due in part to unfavorable public opinion of the IWW. The 1927–1928 strike represents the last hurrah of the IWW in Colorado and the final major labor dispute in Colorado's coal-mining industry.

CF&I continued to be the Rocky Mountain region's chief heavy industry through much of the 20th century. However, the era of the company town began to fade during the 1930s. Both a drop in demand for domestic coal and the rise of automobile ownership resulted in many company towns closing. Additionally, the American steel market nearly collapsed during the 1980s. The last CF&I owned coal mine was sold in 1982, but the legacy of CF&I is still very powerful in Southern Colorado communities.

The photographs in this book are from the CF&I Archives, one of the largest corporate collections available to the public in America. Researchers can use this amazing collection to tell the stories of the growth of industry in the West, the history of technology, western immigration, labor history, the development of industrial medicine, family history, and countless other topics. The CF&I Archives contain a microcosm of American industry with a rare combination of depth, range, and completeness. It was an honor to be entrusted with the early care for this collection, and it is my pleasure to be able to share it with you.

—Jay Trask
CF&I Archivist (2003–2007)

One

LIFE IN A COAL CAMP

The Colorado Fuel and Iron Company (CF&I) owned 62 coal mines throughout its history, and nearly every mine had a company town. These towns were either "open" or "closed." In closed towns, the company controlled almost all of the goods and services, including company homes, company stores, and company doctors. An open town was close enough to an established settlement to not need all of these. About half of all CF&I towns were open.

In the early days of the company, miners' houses could be little more than shacks, often with dirt floors, and there was no general town planning. Following the creation of the company's Sociological Department in 1901, living conditions in the mining camps began to improve. From the 1910s to the 1930s, the company graded streets, installed streetlights, constructed sidewalks, planted trees, and assisted with sanitation efforts. The beautification of properties was encouraged by company-sponsored contests.

The majority of CF&I's mining camps followed the same design. In addition to family housing, they included a Colorado Supply Company store, medical dispensary, and at least one school, church, and boardinghouse for single miners. In 1915, the company entered into a partnership with the YMCA and began to build small clubhouses for social activities and entertainment. The clubhouses also served as community meeting places. Living in the canyons of Southern Colorado, physically separated from nearby cities by geography and the elements, residents of most of the mining towns supported their own school systems, with curricula directed by the state board of education. Other structures provided support for the mining work, including offices, powder houses, boilers or pump houses, stables for mules, blacksmith shops, and other necessities.

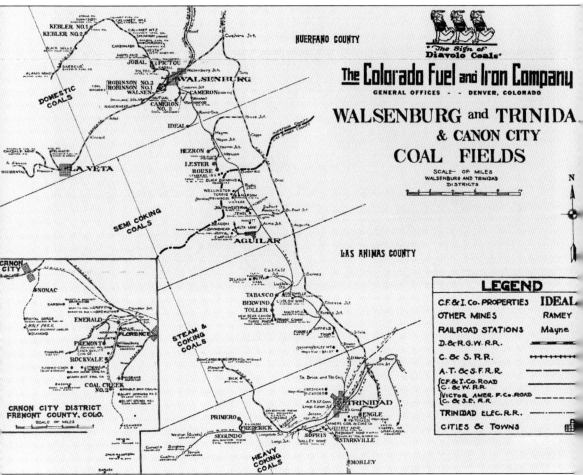

This early-1900s map from the Colorado Fuel and Iron Company (CF&I) shows the locations of coal-mining towns in Fremont, Huerfano, and Las Animas Counties—all in Southern Colorado. Las Animas and Huerfano Counties lie to the south of Pueblo, bridging the Great Plains and the foothills to the Rocky Mountains, including the communities of Walsenburg and Trinidad. Fremont County lies to the west of Pueblo, including the Arkansas River canyon and Canon City. The abundance of coal veins in these three counties, along with their proximity to Pueblo, home of the CF&I steel mill about 35 miles south of Colorado Springs, made them clear candidates for the development of numerous coal-mining operations. This chapter, as well as those that follow, present an intimate view of life in the coal camps. This map is a guide to the geography of these places.

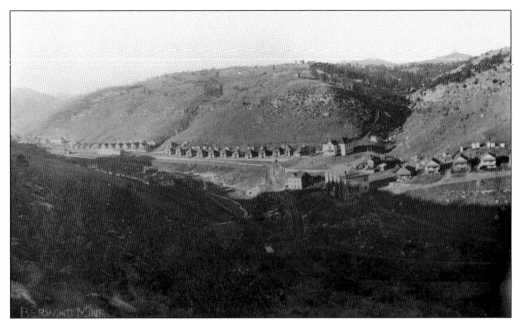

This scenic view of Berwind shows a typical Southern Colorado coal-mining town. Located in Las Animas County, north of Trinidad, it is nestled into a canyon in the foothills of the Rocky Mountains. With little else nearby, it was necessary for these mining towns to be as self-sufficient as possible.

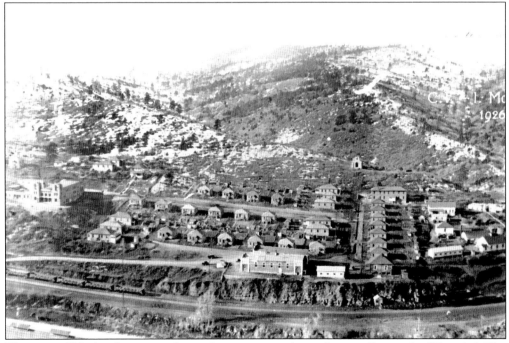

This view of Morley shows a similar coal-mining town, located in a valley south of Trinidad. The photograph clearly depicts a number of elements of a CF&I company town, including company-constructed housing in the foreground, the Colorado Supply Company store on the left, and the St. Aloysius Church perched on the hill in the back.

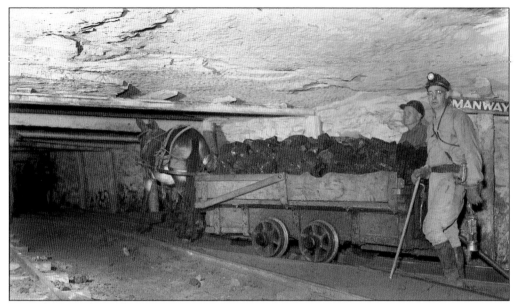

This photograph, made in 1944, shows two miners inside the Cameron Mine, located just south of Walsenburg. They stand next to a cart filled with coal with a mule hitched to the front. Miners spent long hours working underground in cramped quarters. Mules were used for transporting coal in many of the mines, even into the mid-20th century.

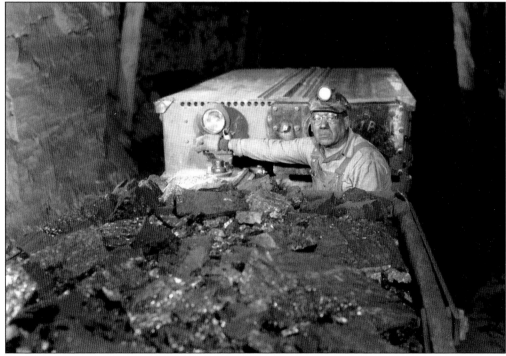

A worker operates a coal cart inside the Morley Mine sometime in the 1950s. Although the Morley Mine made extensive use of mule power and was one of the last mines to do so, electric-powered carts were later introduced. Even so, the inherent dangers of working underground with potentially explosive gases in the air required great diligence.

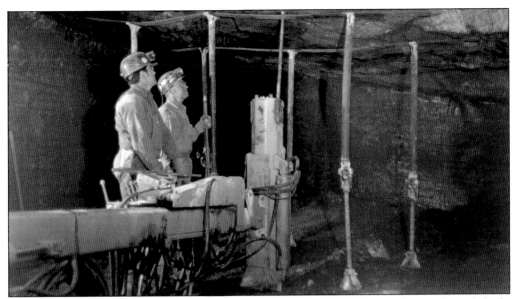

These miners, inside the Allen Mine west of Trinidad, brace the mine ceiling with steel shafts and hydraulics. Mine collapses were an ever-present danger in the underground tunnels. Modern methods like these were used in the Allen Mine, but miners in earlier days resorted to more primitive timbering methods.

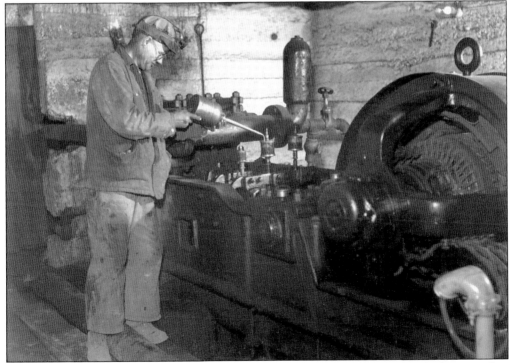

A hoist operator fills an oil reservoir on the hoist at the Morley Mine in 1956, the last year that the mine was in operation. In addition to miners underground, a fully operating coal mine and company town required laborers in many different areas, including mechanics as well as service people to keep the town running.

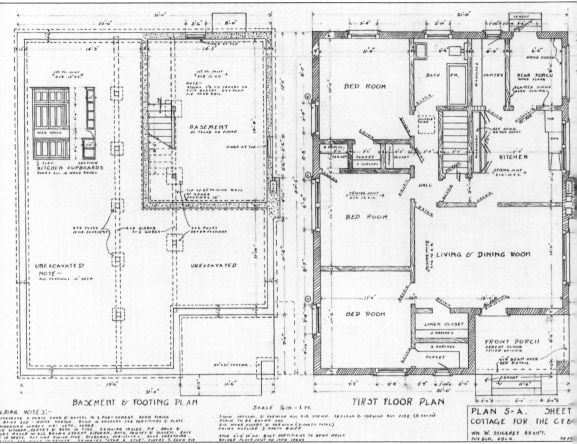

CF&I company houses were typically built on a four-, five-, or six-room floor plan with a central chimney. Many houses were prefabricated and dismantled when the mines closed. Shown here is the floor plan of a typical company-built house from 1917. This home included front and rear porches, kitchen, combined living and dining room, a bath, three bedrooms, closets, and a largely unexcavated basement.

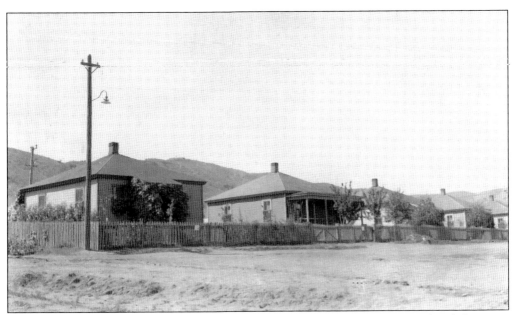

Some of the dwellings erected were provided with baths and some were equipped with furnaces. The majority of houses were made of cement blocks or brick, although the company did build a few frame houses. The typical four-room home cost $700 to build, like these houses shown at Frederick in 1924.

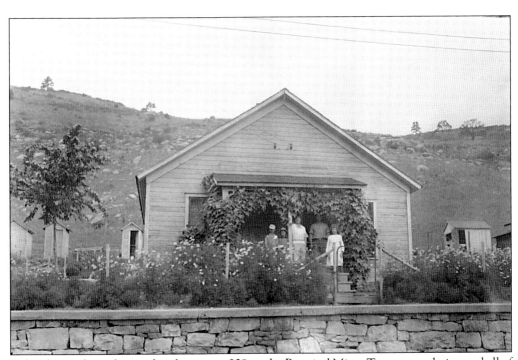

A family stands on the porch at house no. 239, at the Berwind Mine. Town maps designated all of the company owned homes by number. This is an example of the less common frame houses. Only a few of the houses had indoor plumbing. Outhouses were quite common, as seen in the back.

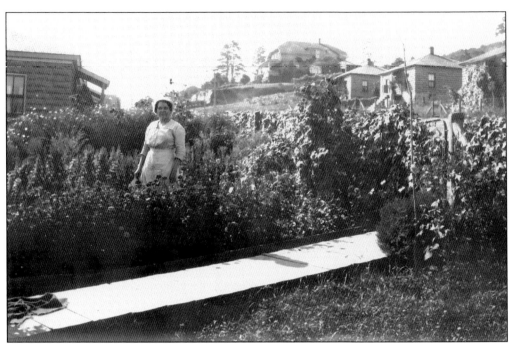

From the 1910s to 1930s, the beautification of properties was highly encouraged by CF&I. Company-sponsored contests among residents expanded to a friendly rivalry between coal camps. Cultivation of lawns, flower gardens, and vegetables was encouraged for beautification purposes. In 1918, Mary Jane Hendricks won a $10 prize for her garden in Morley.

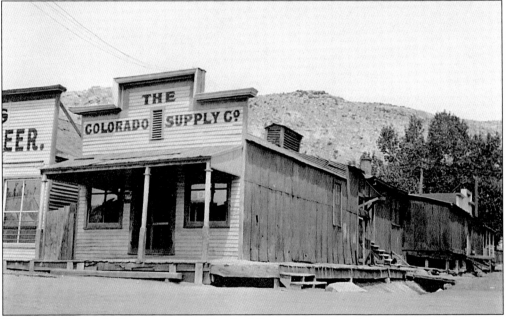

The Colorado Supply Company stores offered a full array of goods and services, selling everything from furniture to clothing. Food departments—with meats and vegetables— were also available. Specialty services included cobblers, milliners, pharmacists, and tailors. Shown here is the Colorado Supply Company store at Rockvale in 1915.

Medical dispensaries, like this one at Primero, treated minor illnesses and injuries. More serious ailments were treated at the company hospital in Pueblo. With the help of nurses, each camp doctor oversaw the dental, optical, and overall medical health of the employees and their families.

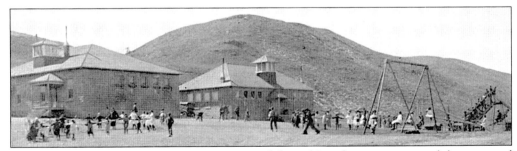

Schools in the CF&I mining towns were part of the public education system of the state and the counties in which they were located. They were not under the control of the company or its officials. Beginning in 1901, kindergartens were established in all schools in the company camps. Shown here is the schoolhouse and playground at the Frederick Mine in 1920.

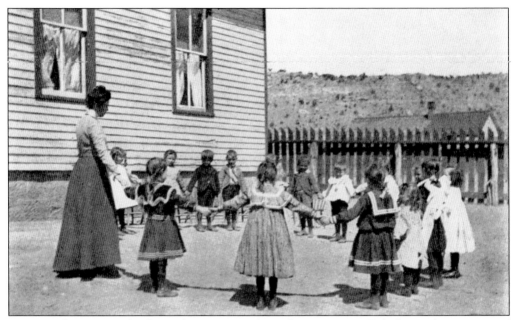

Morning classes at Rockvale Kindergarten are shown here in 1904. With the implementation of the Sociological Department by Dr. Richard Corwin in 1901, a system of educational offerings became common within CF&I's mining districts, including courses for adults and even the youngest children. CF&I's kindergarten curriculum became a model for other large companies.

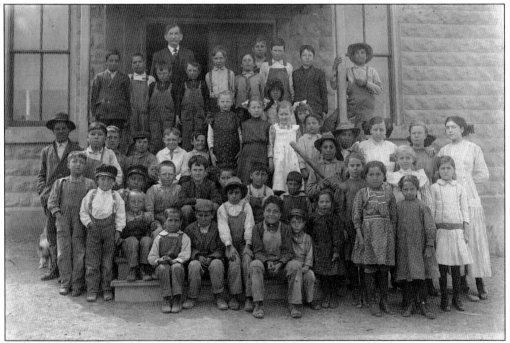

Graduation of the first four-year high school class of a CF&I mining town occurred in the spring of 1920, bringing a new era to public education throughout the mining districts. For many years prior, the public schools at CF&I properties educated children in the primary grades of kindergarten through eighth grade. The teacher and students at the Frederick Mine are shown here.

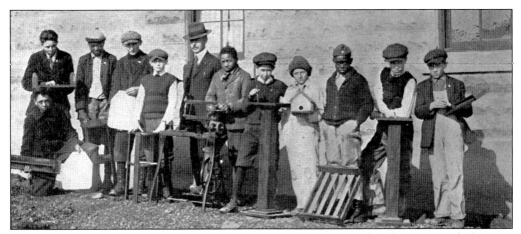

In 1917, Congress passed the Smith-Hughes Act, providing federal funding for vocational education in industrial and agricultural trades. CF&I company town schools used this opportunity to implement a variety of subjects, such as first aid, engineering, sewing, cooking, weaving, gardening, and poultry raising. This is a 1920 class in manual training at the Walsen Public School. By 1926, twelve schools in CF&I's mining districts provided these types of courses.

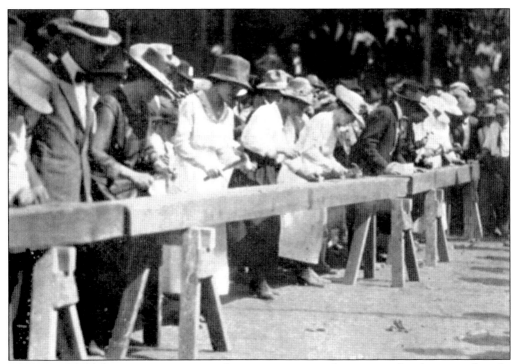

The annual field day was an opportunity for entertainment, relaxation, and making new friends. CF&I sponsored a picnic and a variety of contests and games for its employees once a year, such as this women's nail-driving competition in 1920. Winners were awarded handkerchiefs, cigars, chocolates, fruit, and other small gifts.

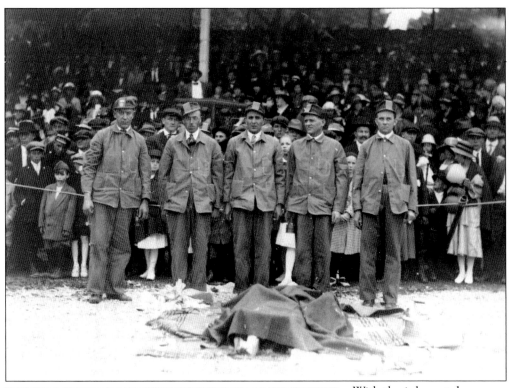

With the inherent dangers of the mining profession, safety and first aid drills and classes were held regularly in each of the mining camps. Here, the Primero Safety Team demonstrates first aid techniques during a public exhibition at the 1920 Trinidad Field Day community celebration.

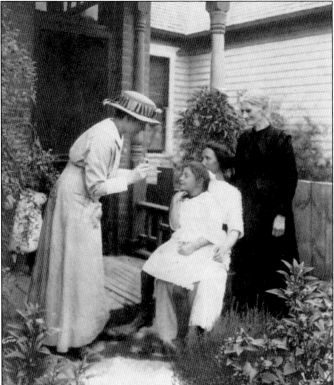

Visiting nurses, like Mary Skrifvars, assisted company physicians in the mining districts. They taught miners' wives about the benefits of clean drinking water, fresh air, a healthy and balanced diet, and other ways to improve the happiness and wellness of home life. Doctors made daily house calls in addition to seeing patients in the dispensaries.

Each YMCA clubhouse was equipped to accommodate large numbers of members for recreational activities, such as motion picture shows, bowling alleys, gymnasiums, libraries, and pool and billiard tables. Refreshment areas sold soft drinks, ice cream, candy, and tobaccos. Industrial, vocational and traditional classes, community meetings, and dances were also held at the YMCA.

STEEL WORKS' Y. M. C. A.
EDUCATIONAL DEPARTMENT
Season 1922 to 1923

Vocational Subjects Taught

Shop mathematics and mechanical drawing, beginning
Shop mathematics and mechanical drawing, advanced
Beginning mathematics
Spanish
Business arithmetic and penmanship
Advanced mathematics
Shop sketching and blue-print reading
Brick and concrete construction

In addition to the vocational classes held under the Smith-Hughes Act, cooking, sewing and girls' clubs classes were organized by the women's secretary who was assisted by 34 volunteer teachers and leaders.

Classes

	First Term	Second Term
Vocational training	7 classes	10 classes
Americanization	1 class	1 class
Cooking and sewing	17 classes	18 classes
Girls' clubs (educational and social)	11 clubs	15 clubs

For both terms the number of classes held were:

Class sessions in vocational classes	385
Class sessions in citizenship	46
Class sessions in cooking and sewing	514
Club meetings - girls' clubs	338

The total attendance in the several classes and clubs was:

In vocational classes	2858
In citizenship classes	845
In cooking and sewing	5460
In club meetings	6533

The largest number enrolled in any one month was:

Vocational classes	131
Citizenship	32
Cooking and sewing	232
Clubs	293

The Discussion Club held eight meetings with a total attendance of 579. Under the auspices of the Foremen's Club eight lectures were given by the heads of the various operating departments. The total attendance approximated 1,250.

Following a CF&I and YMCA partnership in 1915, a variety of courses were offered to employees and their families to learn new skills, trades, or crafts. Americanization classes were also offered to immigrants wishing to become American citizens. This is a 1922 listing of courses offered through the CF&I and YMCA partnership.

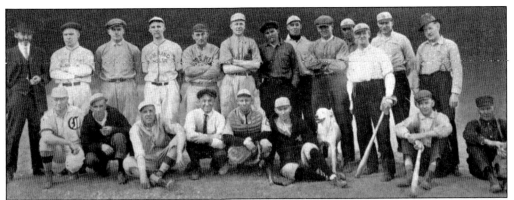

Both management and employees formed baseball teams and played games on an annual basis. On May 1, 1920, the superintendents won the game 9-5 against employee representatives.

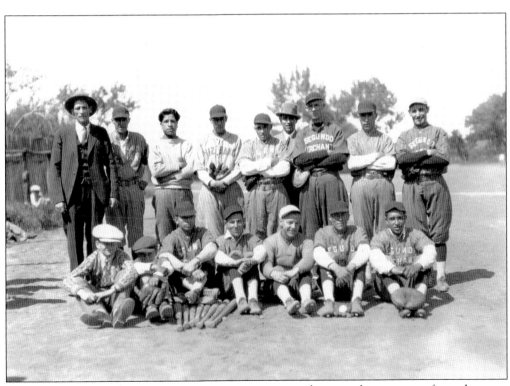

Baseball was a shared interest among mining camp residents, and teams were formed among employees, such as this 1925 Segundo team.

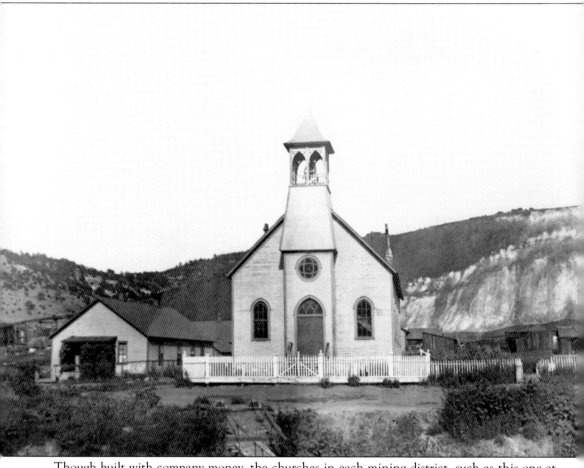

Though built with company money, the churches in each mining district, such as this one at Starkville, were under the supervision of the parishes in which they were located. Some mining districts were able to support both Catholic and Protestant parishes.

Two

PRIMERO

The Primero Mine was opened in 1901 on a seam of coal that averaged six feet thick. The mine and town were located 18 miles west of Trinidad, south of the Purgatoire River, on the former Maxwell Land Grant. Primero was the first of the new mines in the Maxwell Grant, acquired in 1901. It had six openings, all equipped with electric and steam haulage systems.

In this and other ways, Primero was seen as being a model CF&I mine, as well as a model company town. In the October 25, 1902, issue of *Camp and Plant,* the weekly CF&I company newsletter, the editors declare: "Nestled a mile back in the hills that skirt the Purgatoire, Purgatory, or 'Picketwire' River, the town of Primero is most picturesquely situated." Later, they add a description of the view of Primero: "A double row of neat cottages built along a street, parallel with railroad tracks filled with great coal cars, and then off to the left, to the big, black tipple, a hundred yards long, and from there again to the right, along the mine tracks to one of the openings; with its hundreds of model dwellings gleaming in their bright paint of varied colors, its handsome store buildings and its club house. A man accustomed to the miserable towns of the Pennsylvania coal fields and to the coal camps of Colorado's early days, would have difficulty in realizing, as he looked from this hillside, that the bright neatly laid out and comfortable village below him was really a town of coal miners."

The text focuses on Primero first, not because its name suggests it should be first, but rather because it is a mine and a town about which much is known from the work of archeologists who have explored the site within the past 10 years. Please note that Primero is now located on private property, so entry onto the site should not be attempted without permission.

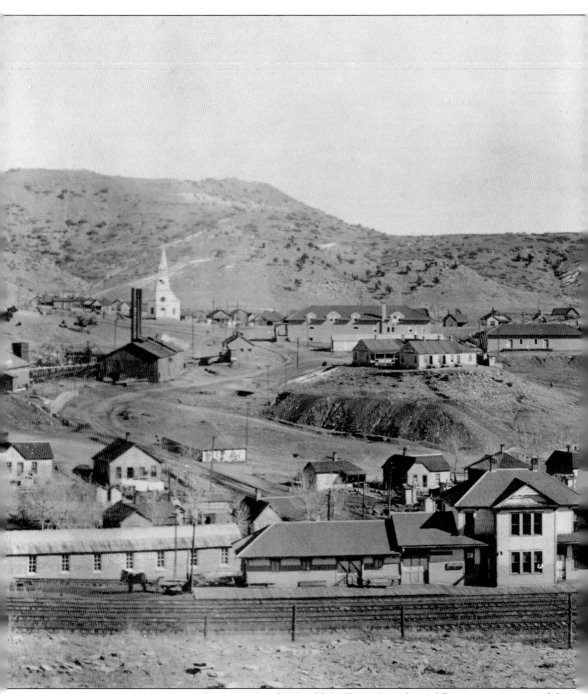

Primero was an early planned community, designed by CF&I's Sociological Department as a model company town. In this panoramic view, much of the town is visible, including the Colorado and Wyoming Railroad station and rows of housing in the foreground, the Catholic church in the upper left, Colorado Supply Company store in the center, and school buildings in the upper right.

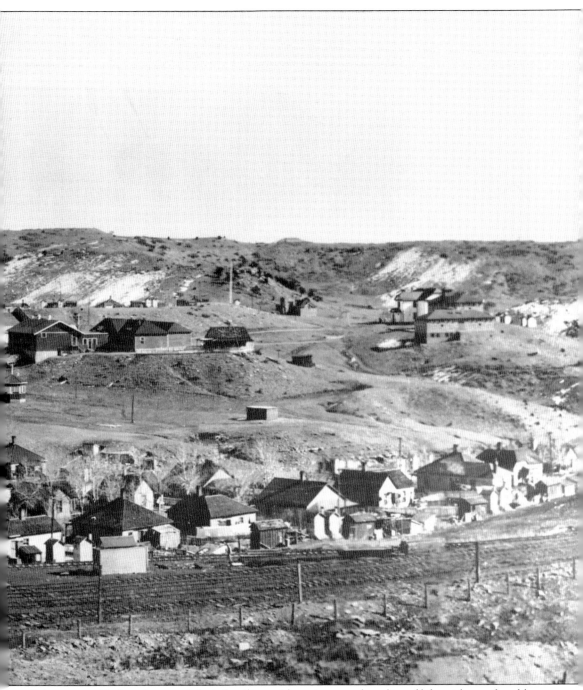

Primero provided workers, and their families, with an improved quality of life, with comfortable housing, schools with very qualified teachers, clubhouses, and other amenities. By 1922, there were about 600 miners and their families living in the Primero company town.

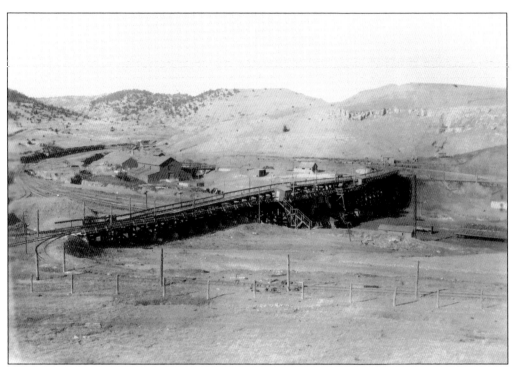

The Primero load-out trestle facility, more commonly called a tipple, was handling about 2,500 to 3,000 tons of coal per day by 1922. The coal was hauled from the mine in coal cars and dropped into train cars from the tipple, where it was then transported to the nearby Segundo coke ovens to prepare it for the steelmaking process.

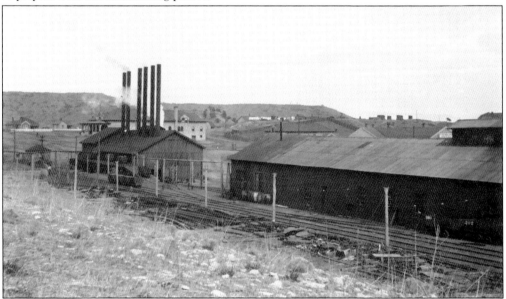

The mine buildings at Primero are shown around 1915. Originally named Smith Canon Mine, and later the Purgatory, it received the name Primero in 1902. The mine was used primarily to produce metallurgical-grade coal, which was sent to coke ovens at Segundo. When Primero ended production in 1925, it had produced 8.2 million tons of coal.

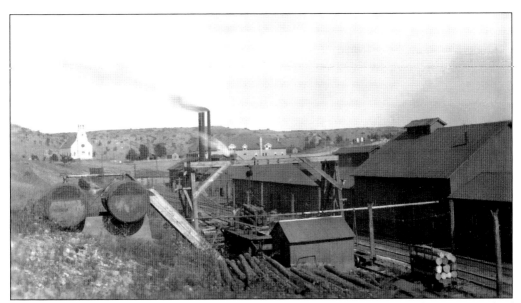

Sizable quantities of timbers were needed to provide structural bracing inside the mine, much of it obtained from the Rocky Mountain Timber Company, a CF&I subsidiary. Shown here is the facility for processing the timbers. In the background, clearly visible, is the Catholic church at the edge of the townsite.

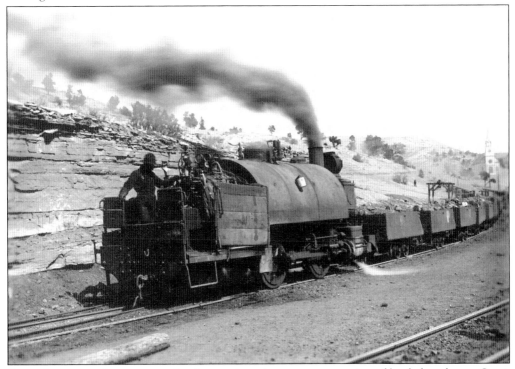

A conductor stands on a steam haulage train as it transports a string of loaded coal cars. *Camp and Plant* reports that "a large new 'dinky' has arrived, and if a sufficient supply of water can be obtained all three of these miniature locomotives will be utilized in 'pulling coal'." The use of steam engines at Primero was considered one of many factors that made it a model CF&I mine.

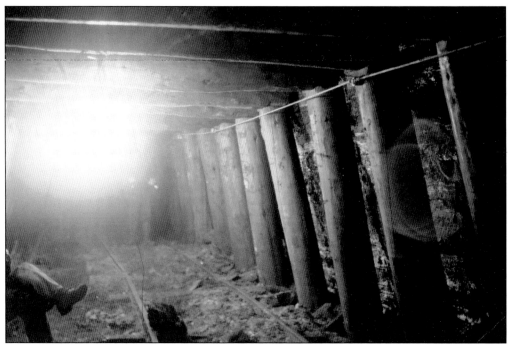

A line of timbers supports the roof of one of the myriad tunnels that made up Primero. The underground workings of a coal mine could be a maze of subterranean passages. The danger of accidents was very real. On January 23, 1907, twenty-four men lost their lives in an explosion, and there were 75 fatalities in a second one on January 23, 1910.

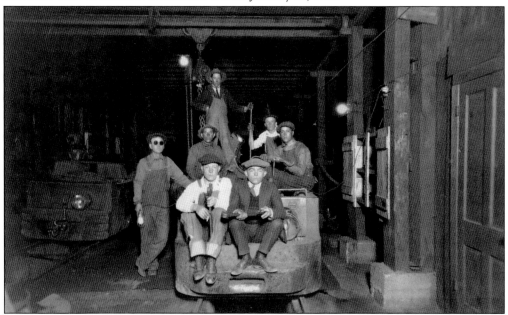

A December 1901 issue of *Camp and Plant* reports: "Most of the machinery for the powerhouse is on hand and as soon as the dynamos can be put in operation the dinkies that are now pulling coal trains will be replaced by noiseless and powerful electric motors." Here, an electrical crew poses with a piece of the modern equipment.

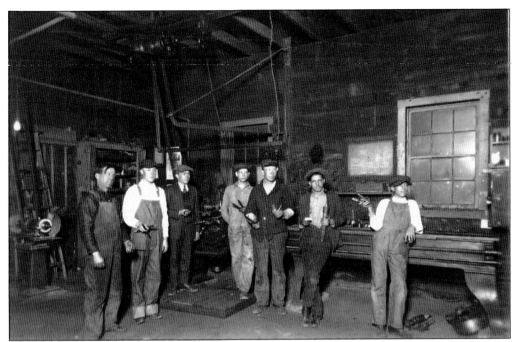

A group of men poses in a Primero mine building. There were many jobs for workers in the mining camps that did not require work underground. Maintenance on machinery was a vital cog in the efficient operation of a coal mine.

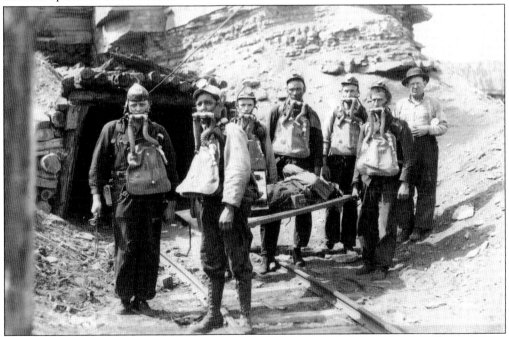

Safety issues were paramount in the lives of coal miners. The potential for collapses or gas explosions was a constant concern and were taken very seriously. CF&I encouraged safety with frequent training exercises. Here, a mine rescue team outfitted with gas masks and a stretcher practices safety techniques outside the mine entrance.

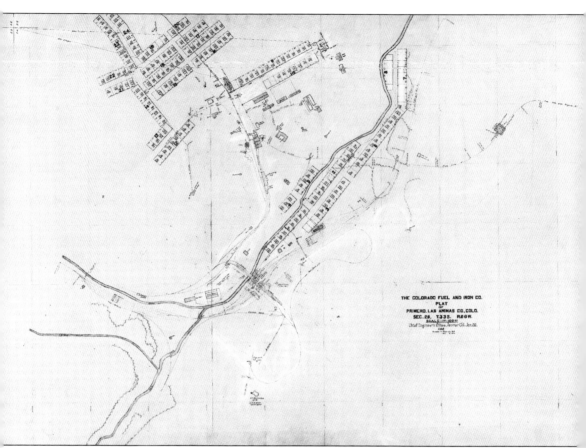

This plat of the Primero townsite is dated January 1902. The original is approximately three by four feet, hand-drawn on canvas. With great detail, it shows the locations of mine structures, railroad lines, schools, churches, the company store, and individual homes, each with a unique number assigned to it. This map has proved to be an invaluable resource for research about the Primero company town, and these types of maps are available in the CF&I Archives for many of the townsites described in this book. The selection of photographs that follow gives details about the particular homes indicated on the map, along with selections from *Camp and Plant* reports that illustrate the daily lives of the people who lived there.

Pete Gordon's house no. 10 won a third prize of $5 in the camp beautification contests. *Camp and Plant* reports: "One hundred houses are practically completed and two hundred and fifty more have been contracted for. At this rate we shall soon be a city of the first-class."

Pictured here is house no. 32. *Camp and Plant* reports: "Primero will be the largest coal camp in the state. A large number of model cottages are being erected for the miners."

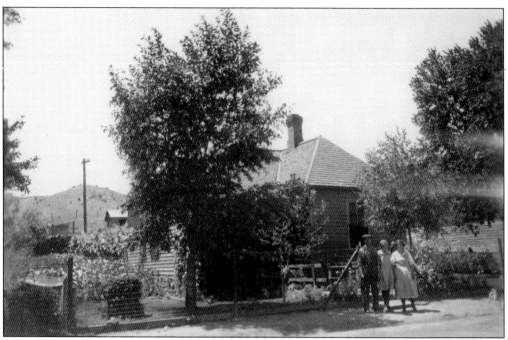

House no. 4 won a third prize in the camp beautification contest. *Camp and Plant* reports that "plain board 'box-car' houses are quite the fashion in the east canon. These are all put up by private enterprise and, though they are comfortable enough, they do not compare very favorably with the houses erected by the company."

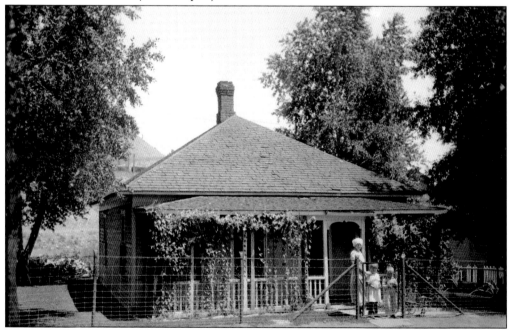

House no. 40 won a first prize in the camp beautification contest. *Camp and Plant* reports that "Primero has one saloon and this will soon be transferred to a large new building south of the company store. About 150 houses are now completed and occupied and the demand greatly exceeds the supply."

Pictured here is house no. 42. *Camp and Plant* reports, "Ground is being broken on the hill west of the tracks for the first dwellings that have been undertaken on that side of the camp. A double line is also being extended down the canon on either side of the arroyo."

Pictured here is house no. 54. *Camp and Plant* reports, "The order has gone forth for all 'box-car' and other shanties to be torn down and henceforth all residents of Primero will live in the new model dwellings the company has provided. There are two hundred of these and more will be built if necessary."

Outhouses, like this one photographed in 1926, were common in the mining camps. Adequate sanitation systems were missing from most camps, and residents commonly threw waste into the yards and streets. Camp marshals were responsible for monitoring waste disposal. Garbage receptacles, emptied and transported to local dumps twice each week, were provided as a community service.

Dr. Richard Corwin joined CF&I as the chief surgeon in 1881. He was a pioneer in the development of industrial medicine, leading CF&I in its efforts to provide company-sponsored medical benefits for its workers. A 1902 *Camp and Plant* reports, "Dr. L. B. Pillsbury, also surgeon for Segundo, looks after the health of the 420 men employed in the mine." This postcard of the dispensary illustrates the pride that the company had in these pioneering efforts.

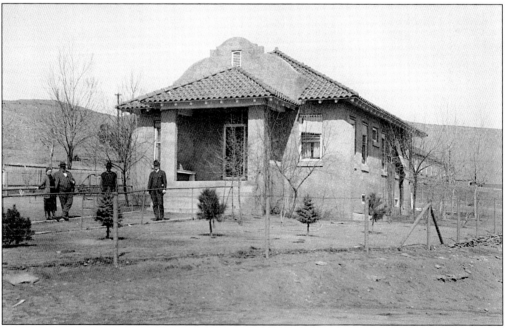

The Catholic church at Primero was erected in 1915, largely with funds donated by John D. Rockefeller Jr. Primero had a substantial Italian and Austro-Hungarian immigrant population, and the majority of the townspeople practiced the Catholic faith. The woman climbing the hill to the church is likely the wife of a miner.

As in many of the coal camps, CF&I operated a Colorado Supply Company store at Primero. Most sales consisted of general merchandise, but the stores also conducted other activities. Most were post offices, with the local managers serving as postmasters. Many stores also offered banking services, issuing one-year certificates of deposit at four- to five-percent interest annually to encourage thrift and savings among the miners.

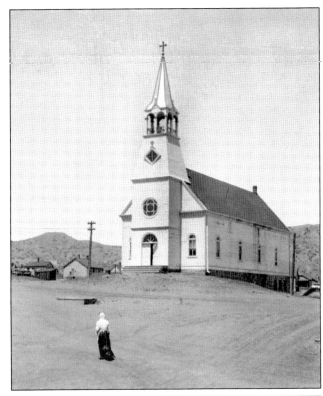

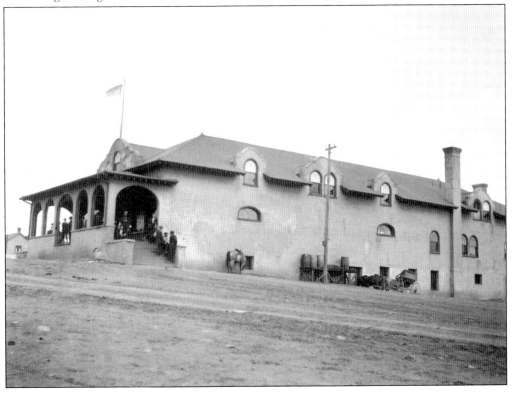

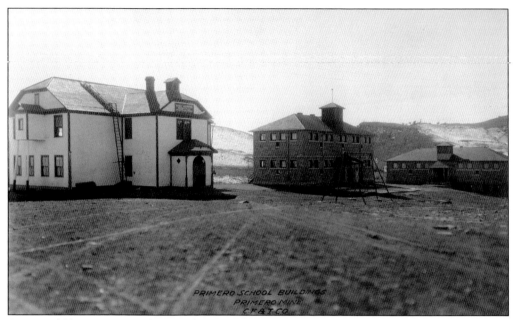

Camp and Plant reports: "A beautiful site on the crest of a hill commanding a view of the country for miles has been set aside for the permanent school house, which will probably be two stories in height and of four rooms, similar to the school building at Pictou and Berwind." Eventually, Primero would host three schools—from left to right, elementary, junior high, and high.

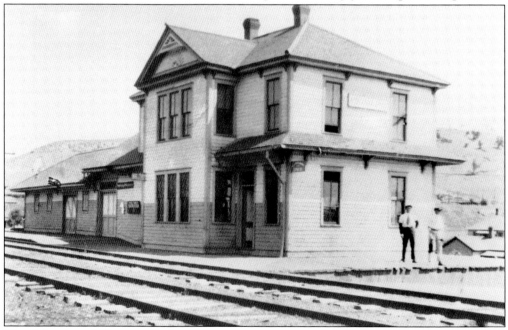

The Colorado and Wyoming Railway ran two passenger trains daily between Primero and Trinidad, in addition to the freight trains. Each morning, a "school train," with one locomotive and one passenger car, transported students between Valdez, Segundo, and Primero. Grade school students traveled to Valdez, while high school and junior high students went to Primero. The train began in 1916 and ran for a decade. Shown here is the train depot.

Three

LAS ANIMAS COUNTY

For over 100 years, 17 mines owned by CF&I dotted the landscape of Las Animas County. The Engle Mine, originally named El Moro Mine, was the first company-owned mine. It opened in 1877, under the ownership of the Southern Colorado Coal and Town Company, one of the companies that would later merge to form the Colorado Fuel and Iron Company. One hundred years later, in 1977, the Maxwell Mine became the first new mine opened by CF&I since 1950.

The majority of the 17 mines and mining towns in the county were located near Trinidad, Colorado, along the Purgatoire River—including Primero, Starkville, Tercio, Engle, Frederick, Sopris, Morley, Allen, and Maxwell. The coal found in this area is a high-grade bituminous type, which is ideal for use in steelmaking.

To make steel, coal must first be heated to extremely high temperatures to remove impurities. During the late 19th century and early 20th century, this was done in brick coke ovens. A few mines in the Trinidad area had coke ovens on-site, but much of the mined coal was sent to coking centers near Trinidad. Coke ovens at El Moro were in operation from 1877 to 1907, and the 800 coke ovens at Segundo operated from 1901 to 1929. The coked coal was shipped by rail to Pueblo, where it was transformed into the steel that built the American West.

CAMP AND PLANT

VOLUME I SATURDAY, MAY 17, 1902 NUMBER 23

EL MORO

One of the Oldest Camps of the Fuel Company
Established Twenty-Six Years Ago

THE EL MORO COKE ovens are located on the Engleville branch of the Denver and Rio Grande, one mile south of El Moro station, 207 miles south of Denver, six miles northeast of Trinidad and 87 miles south of Pueblo, in the west central part of Las Animas county, Colorado. The coal for making coke comes from Engle, which is six miles southwest of the ovens.

Early History.

In May, 1876, the Denver & Rio Grande Railroad was built into El Moro. The track was narrow gauge and remained so for several years; then a third rail was laid, and finally the narrow gauge was abandoned altogether, and the road became and is now a standard gauge.

El Moro was soon a thriving town; it was the terminus of the road—the line into Trinidad not being built until 1882—and as the Denver & Rio Grande was the only railroad in this part of the state, El Moro was a distributing point for an immense territory, including northern New Mexico and part of Texas.

In 1879 the Atchison, Topeka & Santa Fe Railroad Company extended its line into New Mexico. El Moro's palmy days were then over and her glory soon departed. A small sized war between the Rio Grande and the Santa Fe occurred when the latter road attempted to cross the tracks of the former, at El Moro.

The El Moro Coke Ovens.

Meanwhile in 1876 the Colorado Coal and Iron Company had built six coke ovens about half a mile south of the town, and north of where the ovens now stand. These

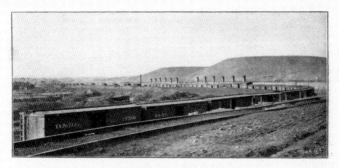

General View of the Coke Ovens.

The feature article in the May 17, 1902, edition of *Camp and Plant* is about the coke ovens and town at El Moro. *Camp and Plant* was a weekly publication distributed by the CF&I Sociological Department (1901–1904) to inform workers and their families about the activities and news at the company's steel mill, coal mines, iron mines, and quarries. The article describes the kindergarten at El Moro quite positively, stating, "On the whole this 'child garden' is in a flourishing condition, its rolls containing the names of twenty one children… Although nearly all are of Italian parentage, they are picking up English quite rapidly and have already exhibited strong tendencies toward American patriotism."

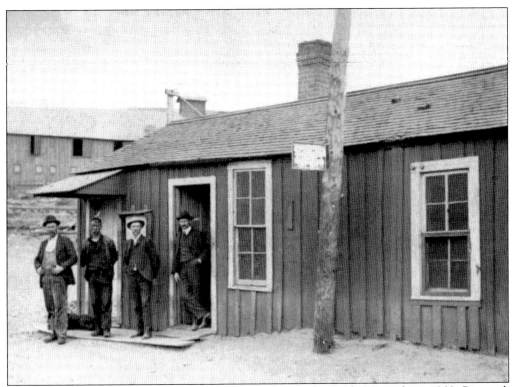

Four men stand in front of the company mine office at the Engle Mine about 1902. Pictured, from left to right, are superintendent James Cameron, pit boss Alexander Jacobs, company doctor T.J. Forhan, and clerk Warren Dow. Cameron also served as superintendent of the Primero and Tabasco Mines during his career with the company.

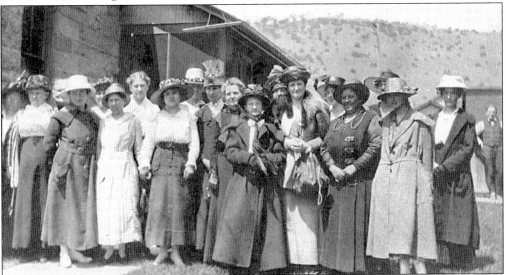

In 1918, CF&I owner John D. Rockefeller Jr. made his second visit to the Southern Colorado coalfields to review working and living conditions in the mines and mining towns. He was accompanied by his wife, Abby, who visited with various women's groups in the mining camps. Abby is the tall woman in the front row of this photograph at Starkville.

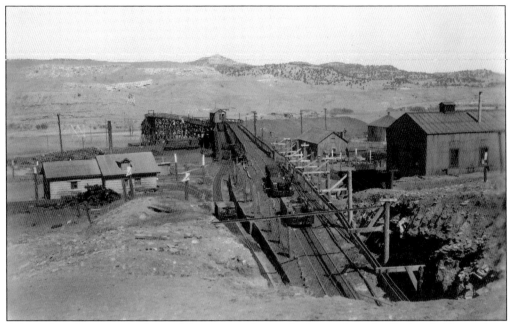

A loaded coal car is pushed out of the mine and towards the tipple at the Frederick Mine, where it will be tipped and emptied of its coal. From 1907 to 1960, over 29 million tons of coal were extracted from the Frederick Mine, more than any other CF&I coal mine.

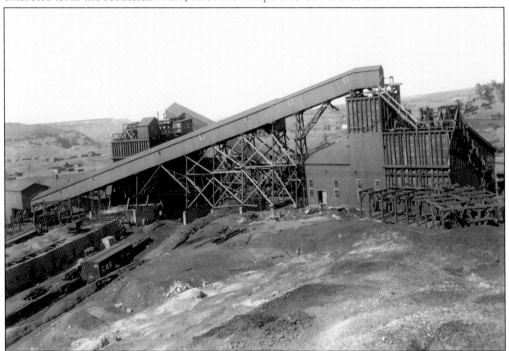

Coal washeries were used to wash newly mined coal of dirt, rocks, and other impurities. Washeries like this one did not become commonplace at mines until the turn of the century. Built in 1909, this washery at Sopris was only in operation for approximately nine years, as individual mine washeries ceased operation in 1918 when a central washery opened in Pueblo.

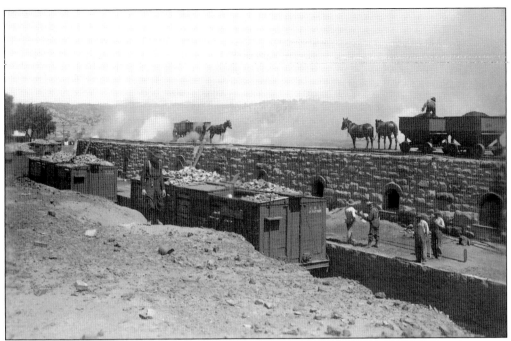

Various mines in Las Animas County sent their coal to Segundo for processing in coke ovens. Coal was loaded in from the top, and intense heating burned impurities out of the coal, turning it into coke, an almost pure form of carbon. The coke was pulled out of the ovens and loaded into train cars for transport to Pueblo, where it was used in the blast furnaces to make steel.

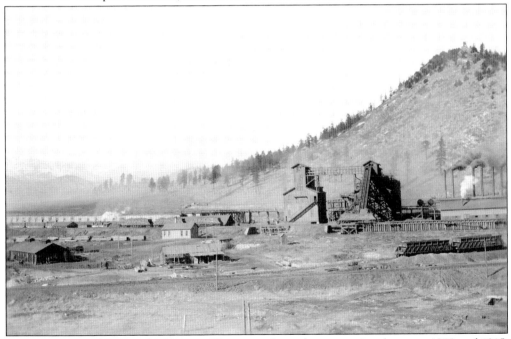

The tipple and other mine buildings at Tercio are shown here sometime between 1902 and 1915, the only years the mine was in operation. During the 13 years it was mined, Tercio produced over 1.5 million tons of coal and over 900,000 tons of coke in the ovens located next to the tipple.

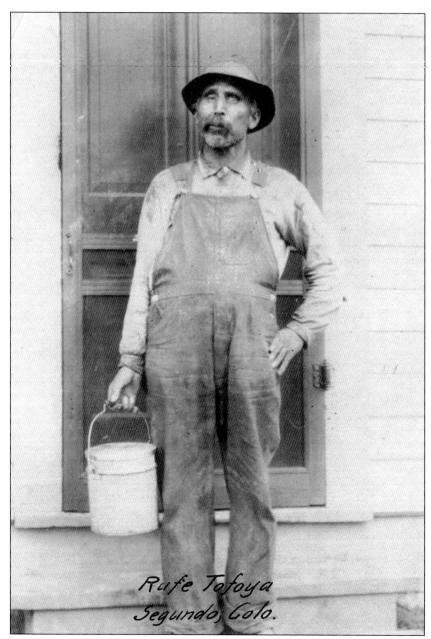

Rufe Tafoya
Segundo, Colo.

Rufe Tafoya began work at El Moro, a coking town north of Trinidad, in 1889. This photograph was made when he retired from the Segundo coke ovens in 1919, at the age of 56. Tafoya's 30 years at the coke ovens were not easy. During his time at Segundo, Tafoya worked long 10-hour days. He and other workers were not paid hourly, but rather according to how many tons of coke they could move in and out of the ovens. A 1903 report of the working conditions at Segundo states that men's pay varied by position, but rates ranged from only $2.05 to $3.10 per ton. The average earnings of coke oven employees were even less than the average pay of a miner. Coke oven work was grueling and dirty, and there was (for a time) only one place in Segundo to take a bath, which was at the barbershop. Baths were not even free. Each cost 25¢, not an insignificant amount to low-paid workers.

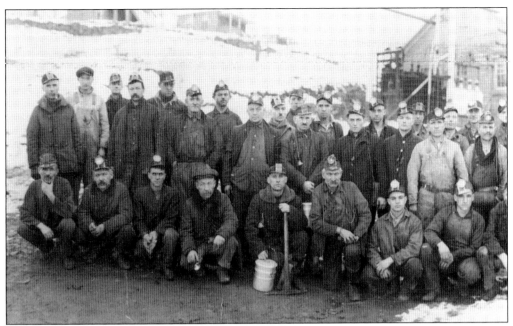

A group of miners poses outside of the Sopris Mine in 1924. They all wear their mining gear, including heavy coats, work boots, and headlamps. Men of various ages worked side by side in the mine. Many started working in their teens and retired in their 50s or 60s.

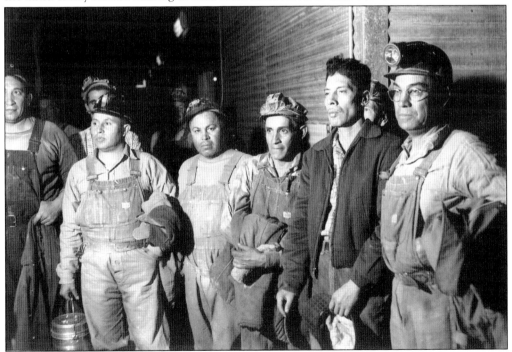

This 1959 photograph shows miners dressed for work underground in the Allen Mine. The Allen Mine was one of the last coal mines that CF&I opened. It was named after Charles Allen Jr., who took control of the company from the Rockefellers in 1945. Opening in 1950, long after most other CF&I mines had been closed, the Allen Mine was in operation until 1981.

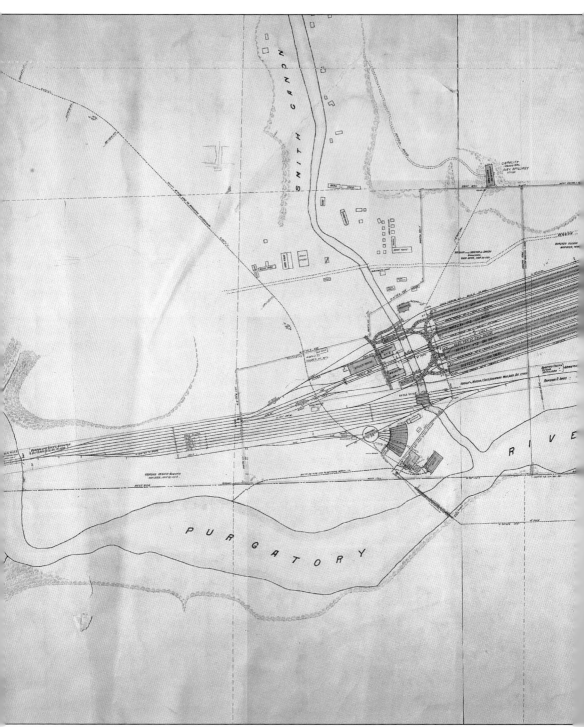

In the long list of professions held by CF&I employees were surveyors and draftsmen whose job it was to create maps of company sites. CF&I created thousands of maps, many of which were hand-drawn and hand-colored, like this 1903 map of the coke ovens and town at Segundo. The four sets of slightly curved lines near the center of the map are four rows of 200 coke ovens. To

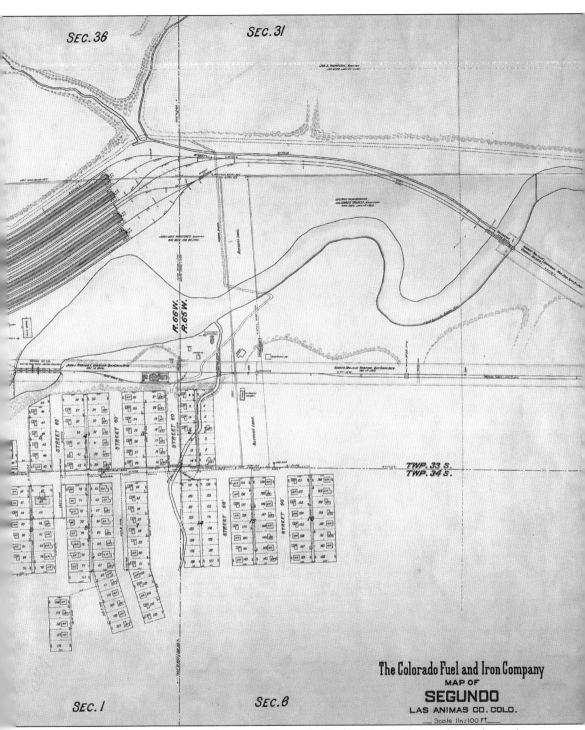

SEC. 36

SEC. 31

SEC. 1

SEC. 6

R.66 W.
R.65 W.

TWP. 33 S.
TWP. 34 S.

The Colorado Fuel and Iron Company
MAP OF
SEGUNDO
LAS ANIMAS CO. COLO.
Scale 1 in. = 100 ft.

the southeast of the coke ovens is the town of Segundo. Each of the 166 house plots indicates how many rooms the houses had (three, four, or six). Running in between the ovens and the town is the Purgatoire River, labeled with the common Anglicized version of the name, Purgatory River. At the time this map was created, approximately 1,500 people lived in Segundo.

47

Built in 1902, the Beaman School was a two-story structure with four classrooms, built almost identically to those in the mining towns of Primero, Berwind/Tabasco, Pictou, and Segundo. Initially, classes were offered only through the fifth grade, but they were later extended through the eighth grade. After only 13 years of use, the school was dismantled with the closing of Tercio in 1915.

Men gather in front of the Colorado Supply Company Store in Starkville. Shown here in 1915, the Colorado Supply Company store in Starkville opened in 1897 and was one of the first company stores opened by CF&I. It closed in the early 1930s, though CF&I closed down the mine years earlier, in 1922.

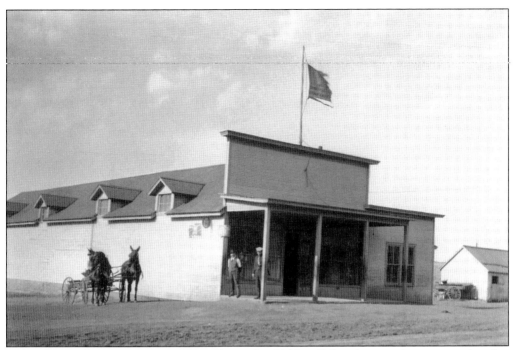

Colorado Supply Company store no. 48, located in Valdez, Colorado, served miners employed at the Frederick Mine and their families. It opened in 1907, one of 21 Colorado Supply Company stores opened during a period of expansion from 1900 to 1908. The store closed around 1960, when mining ceased at Frederick. It was one of the last CSC stores in operation, followed only by stores in Weston, Colorado, and Sunrise, Wyoming, which both closed in 1966. These two photographs, taken around 1915 and in July 1958, show the store near the beginning and end of its lifetime. Perhaps the most notable change in the store is the customers' mode of transportation.

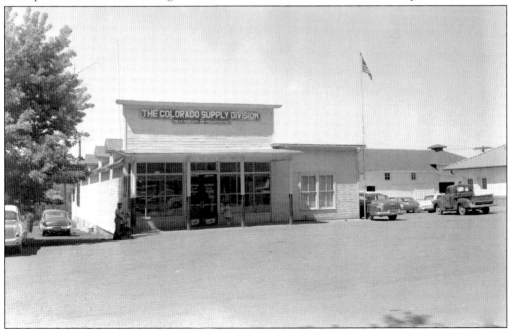

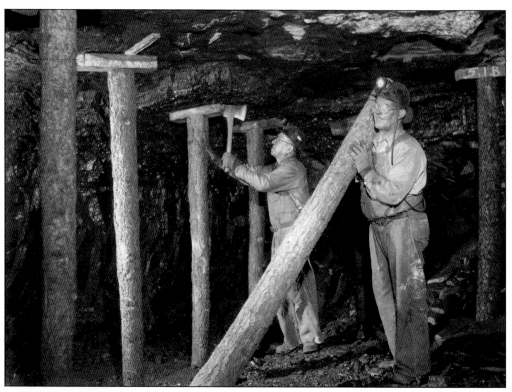

Two miners install timbers in the Morley Mine sometime during the 1950s. These men were part of small workforce employed at the mine. Due to cutbacks in steel production in Pueblo, layoffs occurred at the mine throughout the 1950s, and by 1955, the company only employed 24 men there.

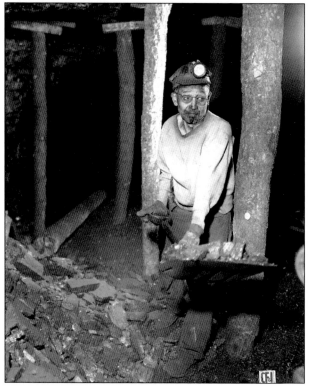

A miner shovels coal in the Morley Mine in 1956. His exhausted expression and the coal dust covering his face and clothes show the grueling nature of mining. He may be removing the coal in order to make space for additional timbers, the wooden posts that surround him. The timbers were used to prevent the ceiling of the mine from collapsing.

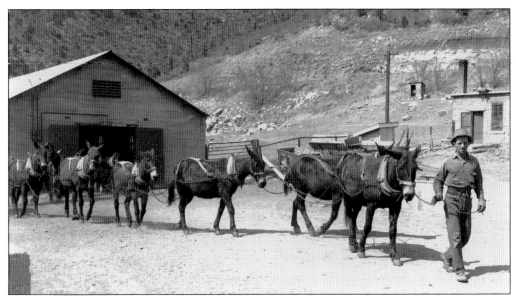

Mules were used to haul coal cars out of mines in the early part of the 20th century, until mechanization became more common in underground mining operations. Generally, the mules were well cared for. The company employed veterinarians to care for sick and injured animals, there was a "mule hospital" in Las Animas County, and rules were in place stating that an employee who abused mules was subject to termination. By the 1950s, Morley was the only CF&I mine still using mules. In fact, Morley may have been the last coal mine in the United States to utilize the animals for coal haulage. These two photographs were taken at Morley in 1956, the final year of the mine's operation.

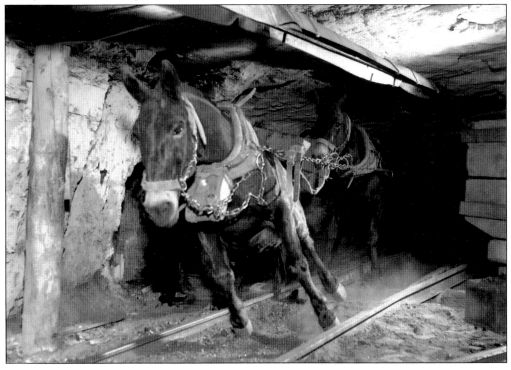

A coal cart waits to be emptied in the rotary dump at the Engle Mine around 1915. Originally known as the El Moro Mine, the Engle Mine was first opened by the Southern Colorado Coal and Town Company, a predecessor company to CF&I. The nearby site of 250 coke ovens, operated by CF&I, retained the name of El Moro until it was destroyed by fire in 1907.

A worker loads supply cars with bags of rock dust near the coal conveyor and silo at the Maxwell Mine. CF&I opened Maxwell to supplement production from the nearby Allen Mine, which was located only three miles away. Maxwell was only open during the years 1977 to 1982 and produced 957,281 tons of coal.

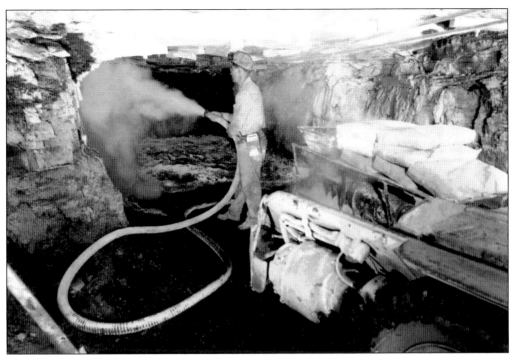

After deadly mine explosions in Las Animas County in the early 20th century, new safety measures were implemented. One of these, rock dusting, was first used at the Frederick Mine. The purpose of rock dusting was to hold flammable coal dust in place and to prevent the spread of flames if ignition did occur. Rock dusting continued to be practiced in the 1950s, when this photograph was taken at Frederick.

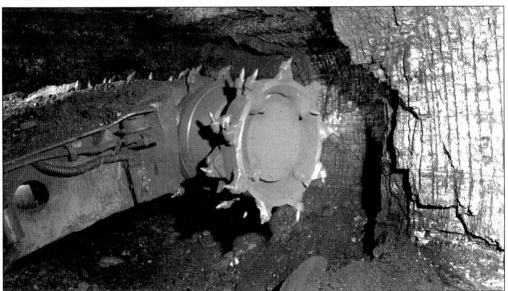

Mining technology changed greatly from the early 20th century to the time the Maxwell Mine opened in 1977. Miners with pickaxes were replaced by continuous miners, which are large machines with rotating steel drums equipped with teeth that quickly scrape large quantities of coal from the walls of the mine. Shown here is a continuous miner in action.

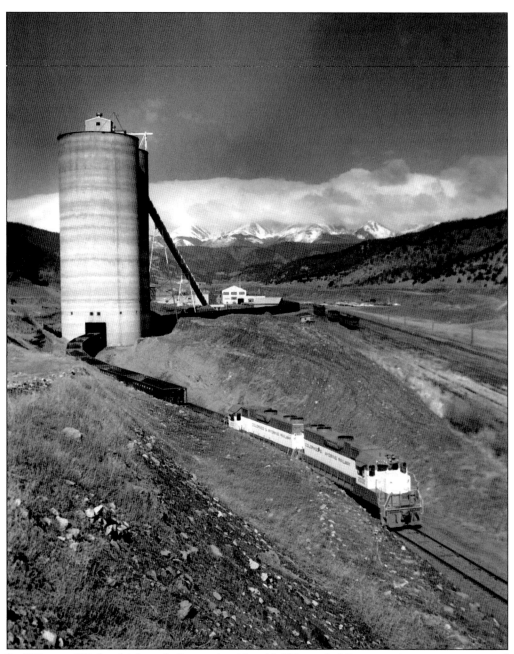

In 1971, two 186-foot-high coal silos, each with a 12,000-ton holding capacity, were constructed at the Allen Mine, replacing a less efficient tipple loading system. All of the mined coal was crushed and loaded into the silos via conveyor and then dropped into unit trains provided by the Colorado and Wyoming Railway. The coal was then transported to the rail-loading yard at Jansen, Colorado, where the train was turned over to the Atchison, Topeka & Santa Fe Railway for the 100-mile journey north. In Pueblo, two identical silos were built to hold the raw coal until it could be processed in the coke plant. The silos at the Allen Mine still stand today and have been used over the years by the companies who have owned the mine since CF&I sold it to the Wyoming Fuel Company in 1983.

Four

BERWIND CANYON

Located in the foothills of the Sangre de Cristo Mountains in Las Animas County, the Berwind Canyon is located approximately 15 miles north of Trinidad, Colorado. Rich in coal, land in and around the canyon was bought up by various mining companies through the late 19th and early 20th centuries. Berwind, developed in 1888, was the first and largest of CF&I's mines in the canyon. Production at the Tabasco Mine began 12 years later in 1900. Toller, the third of CF&I's mines in the canyon, was an already functioning mine when it was purchased by CF&I from another mining company in 1918.

CF&I's Berwind Canyon camps were all located within a few miles of each other and shared schools, churches, and other services. However, they were separate company towns, each with its own post office and Colorado Supply Company store.

As with other CF&I mines, men came from all over the world to work at Berwind, Tabasco, and Toller, creating an eclectic and vibrant community in the otherwise rural canyon. A bustling area for decades, the Berwind Canyon was slowly deserted as CF&I closed its mines there: Berwind in 1928, Tabasco in 1930, and finally Toller in 1932.

Today, the Berwind Canyon is perhaps best known as the site of the 1914 Ludlow Massacre. The brutal culmination of a seven-month strike that pitted miners against mine operators, including CF&I, the massacre came to be one of the most well-known and documented labor disputes in American history. However, the focus of this chapter is CF&I's mines in the canyon and the lives of those who lived and worked there.

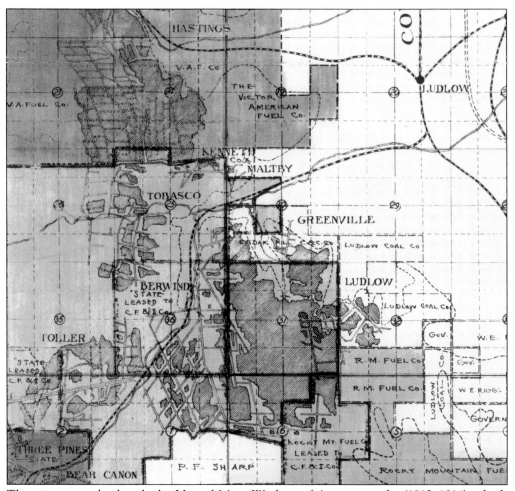

The miners involved with the United Mine Workers of America strike (1913–1914), which culminated in the Ludlow Massacre, labored in mines across the Southern Colorado coalfields, including in the Berwind Canyon area. This section of a land ownership map, created sometime after the 1914 Ludlow Massacre, shows various mines in relation to the site of Ludlow, which was just a few miles from Berwind, Tabasco, and Toller. Forced to leave their company-owned homes in the mining camps, the striking miners moved into the Ludlow tent colony, which was located at the more northerly Ludlow, indicated on this map. On April 20, 1914, after months of tense relations and violence between the strikers and armed guards employed by CF&I, a battle broke out, with the striking miners fighting the Colorado National Guard and CF&I's hired guards. Sixteen people, mostly women and children, died in the melee. The tragedy at Ludlow, and other events during the 1913–1914 strike, ultimately resulted in policies that improved the living and working conditions in mining camps across Southern Colorado.

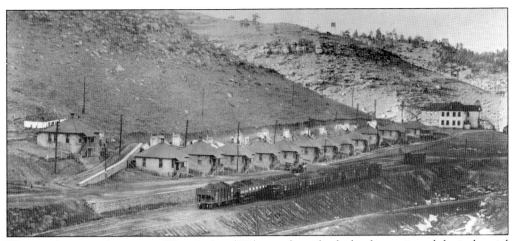

The area between the towns of Berwind and Tabasco shows both the domestic and the industrial aspects of residents' lives. A row of homes, each with its own outhouse, stands near railcars loaded with freshly mined coal. The white building in the background is the Corwin School.

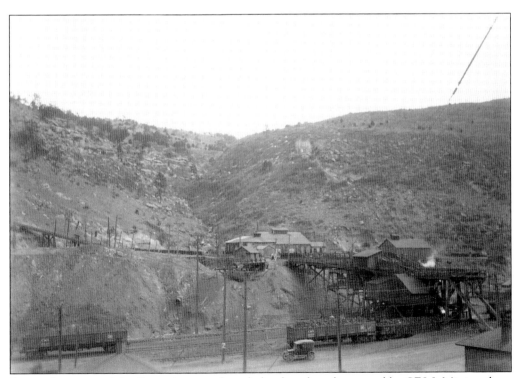

Berwind was one of the first mines purchased, developed, and operated by CF&I. Mining there began in 1890 and ceased 38 years later, in 1928. Initially called El Moro no. 2, the mine was eventually named after Edward J. Berwind, president of the Colorado Coal and Iron Company, the CF&I predecessor company that first owned the mine.

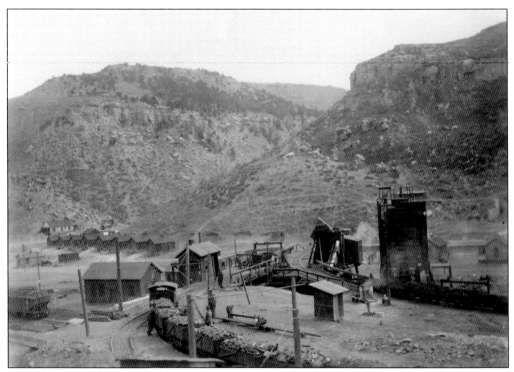

CF&I began mining at the Tabasco Mine in 1900 and ended it in 1930, after over four million tons of coal were extracted from the mine. Unlike some other mines that utilized mule power to pull coal cars out of the mine, Tabasco was equipped with steam-powered hoists that pulled loaded coal cars to the surface. Until 1918, when a central Coke Plant opened in Pueblo, close to 90 percent of the mined coal was processed in on-site coke ovens. Nearly all of the coke was then sent to Pueblo via the Colorado & Southern Railway to be used in steelmaking.

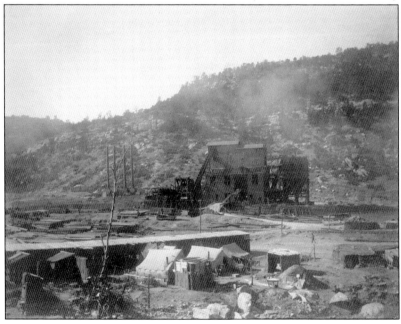

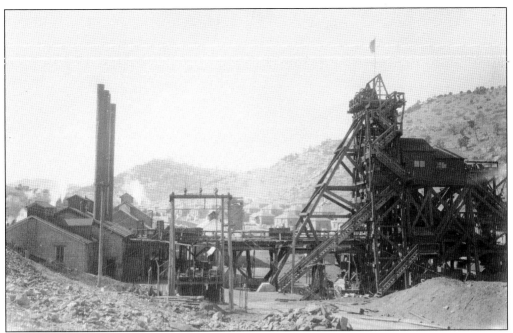

The Toller Mine, shown here in 1923, was located a few miles southwest of the Berwind and Toller mines. It was in operation under the ownership of CF&I from 1918 until 1932. Around two-thirds of the 2,350,000 tons of coal extracted from the mine during this time was sold for use as domestic and industrial fuel, rather than for steelmaking.

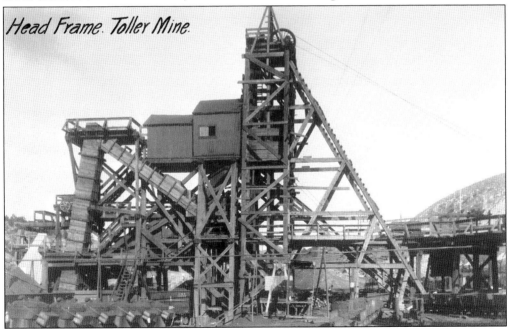

Headframes are structures built at the top of a mine shaft to house hoisting mechanisms, which are used to lift coal, equipment, and even miners out of the mine. This photograph of the wooden headframe at the Toller Mine was taken sometime around 1923. Today, headframes are made of steel or concrete rather than wood.

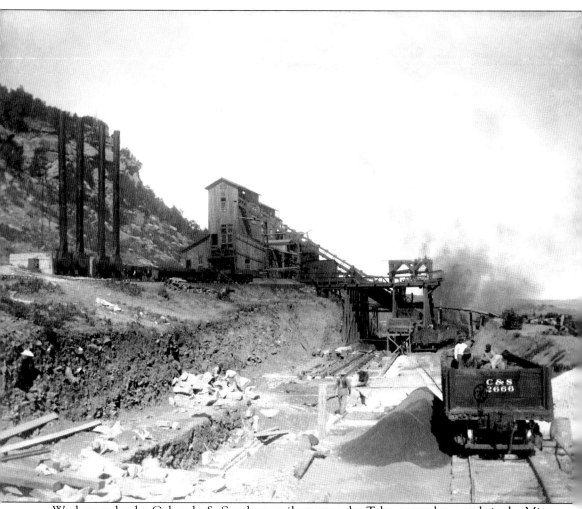

Workers unload a Colorado & Southern railcar near the Tabasco washery and tipple. Mine work did not just consist of underground coal mining. Many men also engaged in physical labor aboveground at the coal washeries, tipples, and coke ovens. Without the risk of explosion, falling rock, or mine collapse, aboveground mine work was generally safer than underground. However, various hazards still threatened these workers. Common accidents included explosions due to mishandling or incorrect storage of explosives, falls from the tipple, and electric shock. Many men also lost their lives after being run over by locomotives and mine cars. Tabasco, like other mines, had its share of tragic accidents. For example, the 1915 *Third Annual Report of the State Inspector of Coal Mines* notes that a 22-year-old machine oiler, Epifanio Ballon, died in 1915 after being pulled into one of the gears of the Tabasco washery.

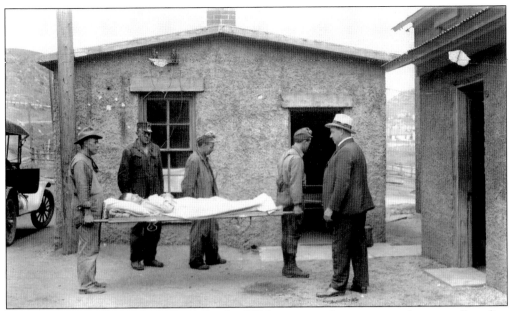

Due to the dangerous nature of mine work, CF&I encouraged its miners to have excellent first aid skills. Each mine had a first aid team that competed against other mine teams in first aid contests. Teams were often instructed by local company doctors. Here, Berwind surgeon Frank Yale (right) watches as four miners practice carrying a man on a stretcher.

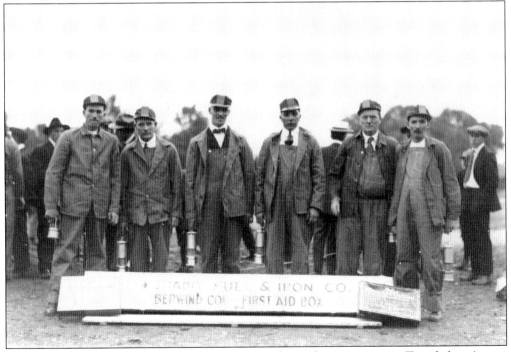

The first aid team from Berwind participated in a first aid competition in Trinidad in August 1924. With a score of 100 percent, the men were the winners of the contest. The box in front of them reads "Colorado Fuel and Iron Co. Berwind Col. First Aid Box." The items on either end are labeled "first aid cabinets."

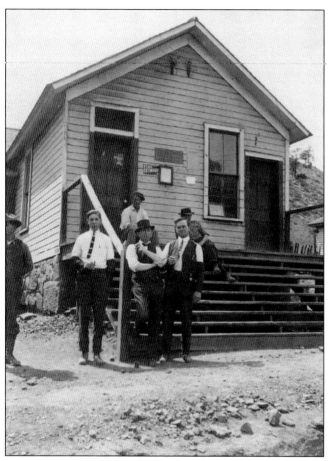

Six men relax in front of the mine office in Berwind around 1917. The three men standing at the bottom of the stairs hold cigars. Their attire suggests that they are white-collar workers, perhaps clerks in the mine office. Wearing coveralls and boots, the man standing to the left is most likely a miner.

Two adults and a group of children pose on the porch of the Berwind YMCA. Also serving the nearby mining towns of Tollerburg and Tabasco, the YMCA was multifunctional, serving as not only a sports and recreation hall, but also as a community center. For a short time, it was the area's Protestant church, until one was built in Berwind in 1922.

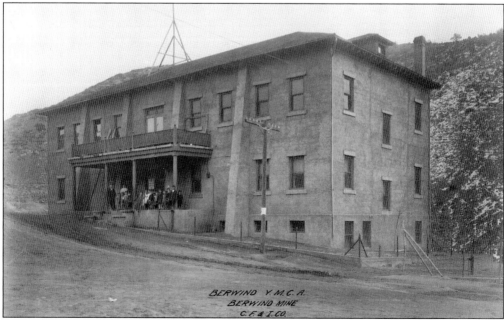

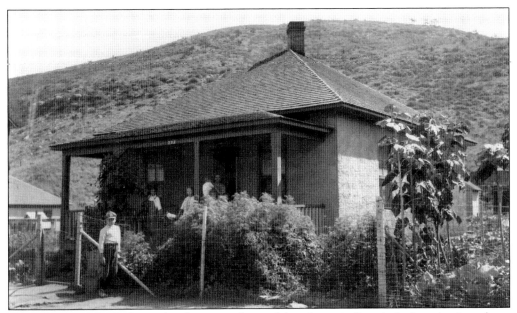

Six members of the DeSantis family pose in front of their home in Berwind after winning a lawn and garden contest in 1918. Such contests had been held in the camps for many years, but they gained added significance during World War I when the US government encouraged citizens to grow food in war gardens.

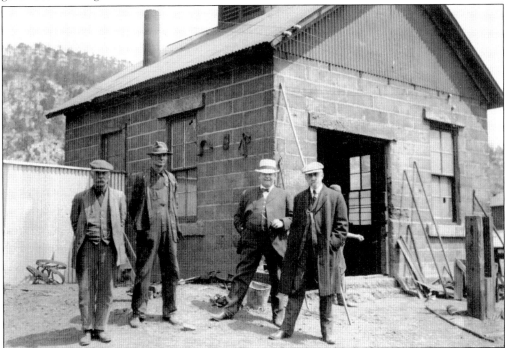

CF&I executives stand in front of the blacksmith shop at the Tabasco Mine, around 1915. From left to right are Starr J. Murphy, counsel for the Rockefeller Foundation and personal legal adviser to John D. Rockefeller; J.P. Thomas, superintendent of the Southern Division Mines; E.H. Weitzell, superintendent of the fuel department; and S.G. Pierson, vice president and purchasing agent.

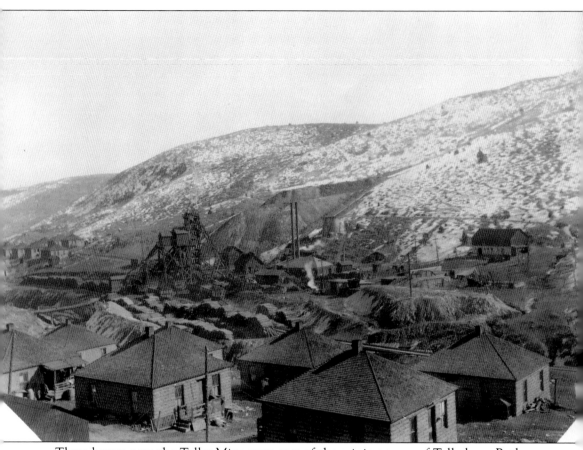

These homes near the Toller Mine were part of the mining camp of Tollerburg. Both camp and mine were named for Giacomo Toller, an Austrian-born businessman who owned the land where the town and mine were located. After immigrating to the United States in 1888, Toller was employed for a short time at the Sopris Mine, owned by CF&I. He probably never imagined he would later sell his land to his former employer. When CF&I purchased the land from Toller in 1918, there was already an operational mine on the premises, owned by the Cedar Hill Coal and Coke Company. In the purchase, CF&I acquired not only the mine, but also a number of buildings in Tollerburg that are described in the *Industrial Bulletin* as "a modern store building, a stone club house, and a number of dwelling houses."

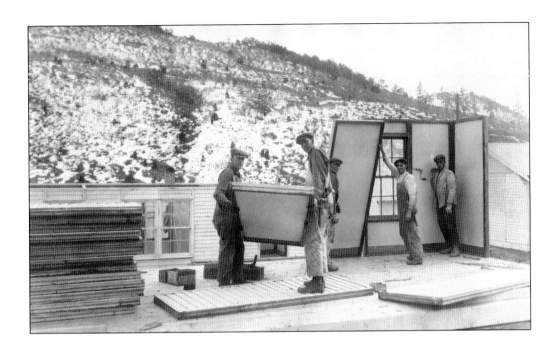

CF&I company houses were typically cement-block or brick structures. However, the company did build some prefabricated sectional houses in Tollerburg. Such housing was quick and easy to construct, and would have allowed miners and their families to move into their new homes quickly. Sectional houses like these would have also been fairly easy to deconstruct and move to other mining towns as needed. By the time these houses were built in the early 1920s, some houses in mining camps were equipped with indoor plumbing, but the outhouses here indicate that the families who moved into these homes probably did not have such a luxury.

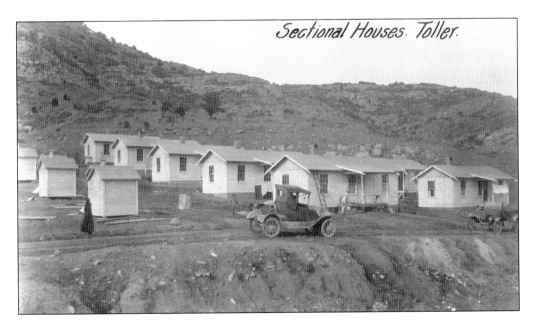

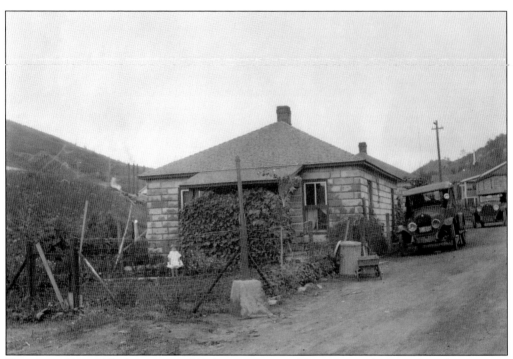

Home no. 60 in Tollerburg won a $10 first prize in a 1924 company lawn and garden contest. The home was rented by Charles H. Lee, a mine hoist operator who also served as an employee representative under the Employee Representation Plan.

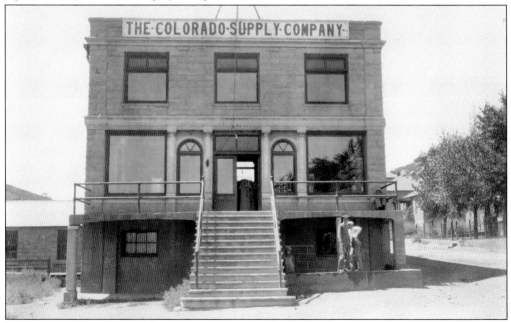

Four boys pose outside of the Colorado Supply Company Store in Tollerburg. Customers at Colorado Supply Company stores could find all of their day-to-day needs, including clothing, which can be seen displayed inside. This store opened on May 1, 1918, and closed in 1932, the same year that the Toller Mine closed.

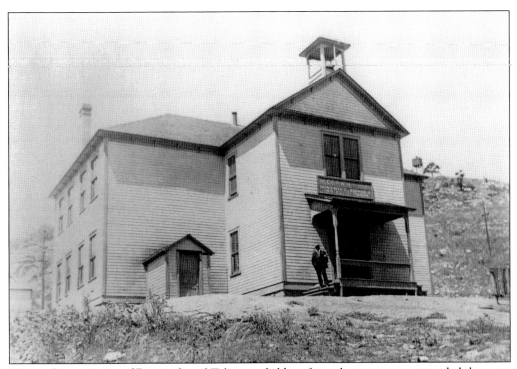

Due to the proximity of Berwind, and Tabasco, children from the two camps attended the same schools. The Corwin School, named after CF&I's chief surgeon and Sociological Department head Dr. Richard W. Corwin, opened in 1902. Shown here about 1910, it was a wooden, two-story structure with a bell tower on the roof. Aside from kindergartens, the Corwin School was the only one serving Berwind and Tabasco until CF&I acquired the nearby Toller Mine in 1918. After this purchase, a school improvement campaign began. Two rooms were added to the Corwin School, and in between the camps, a new junior/senior high school was built. Finally, two school buildings for grades one through five were built at Toller. These are shown here shortly after their completion.

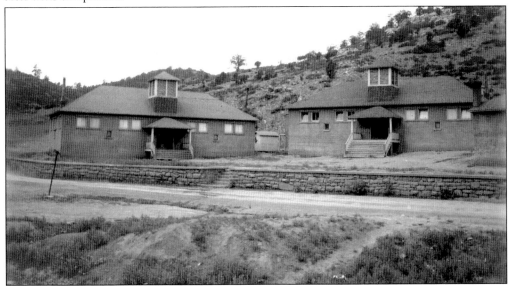

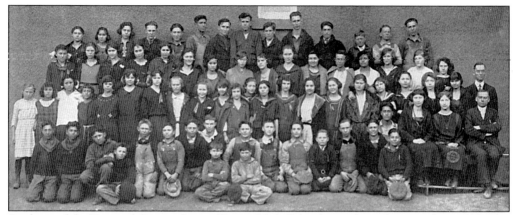

Students of the Berwind Canyon Junior/Senior High School pose for a photograph in 1923. The school served residents of Berwind, Tabasco, and Toller, in addition to the nearby Bear Canon Mine, owned by the Bear Canon Coal Company. This photograph was taken in 1922, one year after the first four-year high school class graduation. Prior to that, ninth grade was the highest a student could complete.

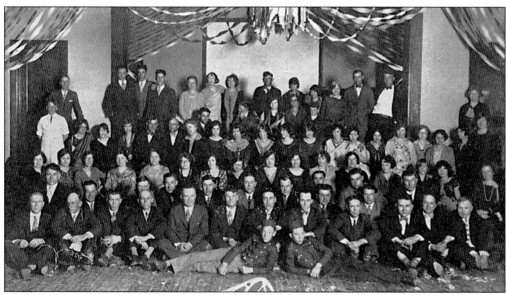

Dances were very popular in all of the mining camps. In 1929, a series of invitational dances were held at the newly constructed YMCA in Tollerburg. Pictured here are attendees of a carnival-themed ball held in February before the beginning of the Lenten season. The evening's program included not only dancing, but also a meal of ice cream, cake, and coffee.

Five

SOUTHERN HUERFANO COUNTY

The dividing point between northern and southern Huerfano County lies at the Ideal camp, centrally located in this county to the north of Las Animas County. Though many mines dotted the region in the 19th and 20th centuries, CF&I owned the Cameron (also known as Robinson no. 4), Ideal, Hezron, Lester, and Rouse Mines. Most of the coal extracted from these was high-grade bituminous ore used in domestic and commercial heating. Of the millions of tons of coal mined each year, a very small percentage was sent to Pueblo to be used in the steel mill coke ovens.

Like many of CF&I's other mining camps, those of southern Huerfano County included mine structures, such as the tipple, headframe, office buildings, powerhouse, pump house, blacksmith shop, mule stables, washery, miners' homes, boardinghouse, dispensary, school, store, and YMCA. Though other mines existed in southern Huerfano County, they were privately owned and operated.

In the days preceding the Great Depression, at the end of the 1920s, coal sales were extremely profitable for CF&I, and it subsidized the steel manufacturing at the main plant at Pueblo. As natural gas took the place of coal for domestic and commercial heating in the Front Range areas of the Rocky Mountains, the need for coal diminished, and the mines that were the least productive were closed. By 1933, only six CF&I coal operations were left, including the Cameron Mine in southern Huerfano County.

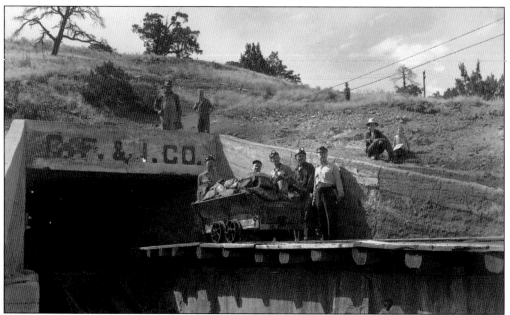

The Cameron Mine was named in honor of James Cameron, manager of the coal mines in the late 1870s and early 1880s. Here, five men, presumably miners, stand beside the coal cart, and a little girl and two young boys stand above the mine entrance. The children are most likely waiting for their father to emerge from the mine portal following his shift.

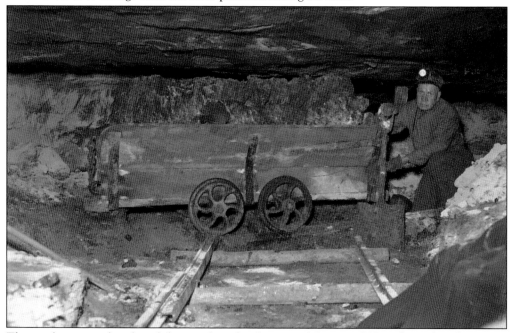

This coal car was abandoned deep within the Cameron Mine in 1889 and was found in 1944. An article and this photograph appear in the *CF&I Blast*, sharing the news of the discovery. Mining equipment could be as simple as carts, picks, and shovels and as dangerous as highly explosive dynamite. As technology improved, CF&I utilized emerging methods and equipment to extract coal.

The Cameron Mine, at its peak production, was said to have employed 300 men, but usually it averaged around 175 men per year. Total production of the mine was nearly four million tons of coal, and of that, more than 760,000 tons were mined between 1936 and 1941. Even though Cameron was a high producer of coal, CF&I did not see the mine as a profitable venture and announced the mine's closure in January 1946. Houses were moved to nearby Walsenburg, machinery was moved to the nearby camp of Pictou, and 40 structures were sold. The tipple was dismantled in 1950.

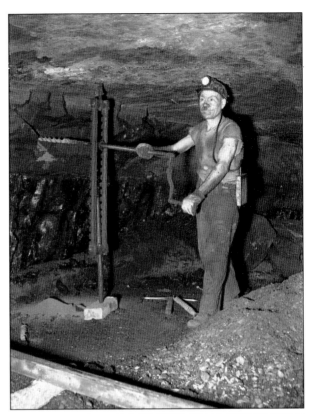

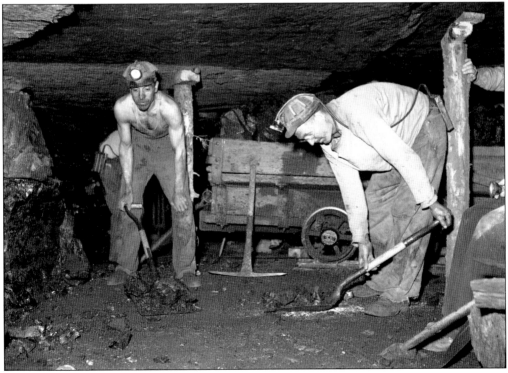

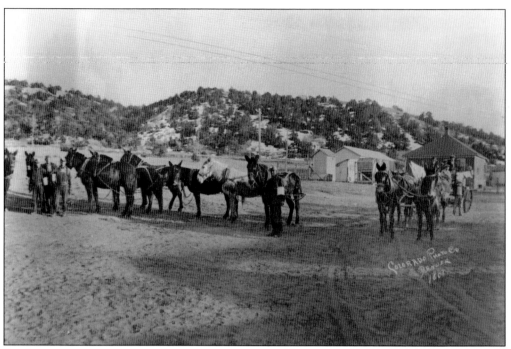

Employees were expected to take every measure possible to treat the mine mules humanely and with good sense. The stables to house the mules in Huerfano County were built aboveground and included stalls with packed earth and plank flooring. Ample provision was made to prevent mules from becoming ill after returning from their work. CF&I publications in the 1950s stated that each mule was fed 16 pounds of oats per day and all the hay that it wanted. Stable bosses and their staff provided clean and ample water and removed manure.

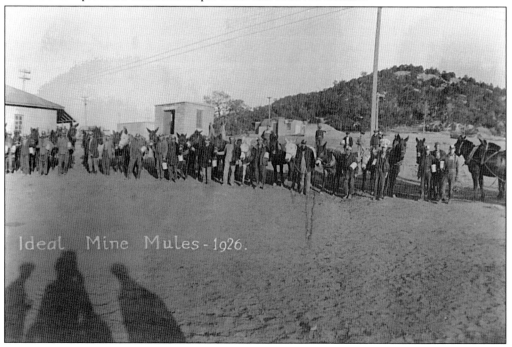

Ideal Mine Mules - 1926.

Shown here is the tipple at the Ideal Mine, located southeast of Walsenburg past the Cameron Mine. The tipple was the basic method for moving coal from the mine to train cars. In this photograph, the railcars are clearly visible waiting for the load of coal to drop from above.

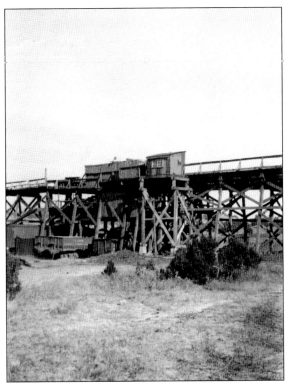

As technology improved, the equipment at the mine site also improved. Basic equipment shown in this photograph includes the conveyor belt to move the lumps of coal from the tipple to the waiting train, and the newer piece of equipment, telephone poles for communication between mines and mine buildings at the site.

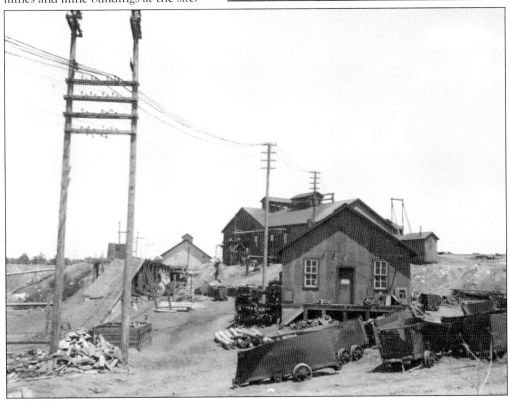

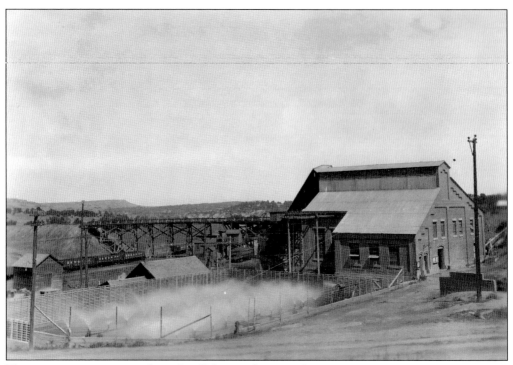

Electricity is an important force for all forms of mining. It is a major energy source to transport personnel, move ore, and power machinery. In addition, electricity is vital to health and safety-related components like pumping water, powering large fans to rid the area of toxic gases, maintaining good ventilation, and providing refrigeration within the underground operations. As early as 1900, CF&I's mines used turbines and powerhouses to fuel mining operations. When needed, CF&I also maintained a fleet of generators to keep operations flowing when electricity was not readily available.

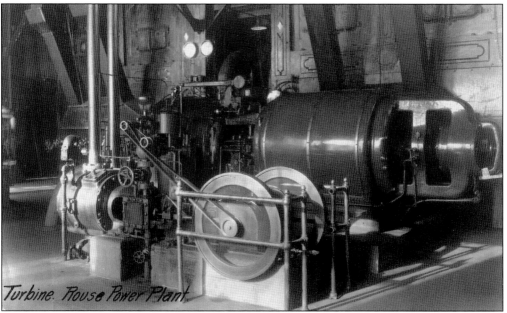

Turbine. Rouse Power Plant.

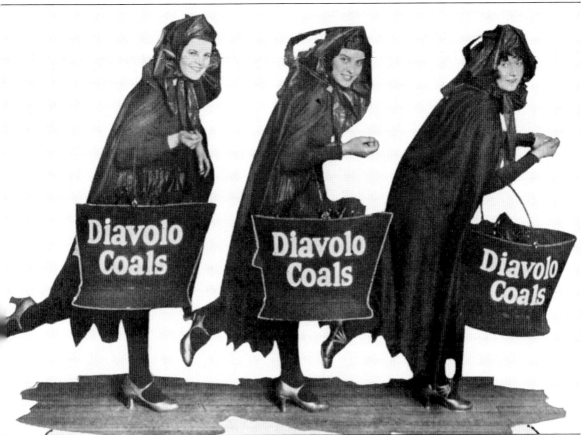

The CF&I advertising department promoted the Diavolo domestic coal brand in many local and regional magazines and newspapers as well as in its own publications. Using a recognizable logo of three devils, the slogan promoted "CF&I Coals for More Heat." Here, three young female models strike the same pose as the devils used in other campaigns.

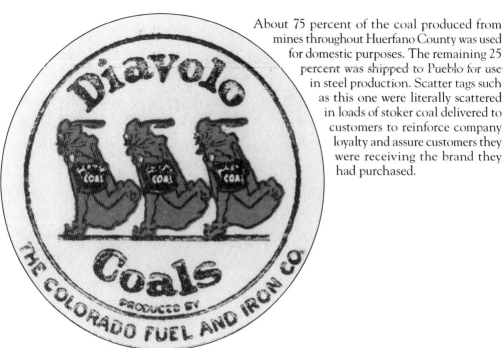

About 75 percent of the coal produced from mines throughout Huerfano County was used for domestic purposes. The remaining 25 percent was shipped to Pueblo for use in steel production. Scatter tags such as this one were literally scattered in loads of stoker coal delivered to customers to reinforce company loyalty and assure customers they were receiving the brand they had purchased.

Between 1899 and 1920, the Rouse Mine produced over five million tons of coal. After excavation, the coal was washed thoroughly to remove dirt and extra debris. The lumps of coal were loaded onto CF&I's railroad, the Colorado and Wyoming, as shown here. The greater part of the coal mined at Rouse was shipped to domestic and commercial customers, with only about four percent used at the CF&I plant in Pueblo.

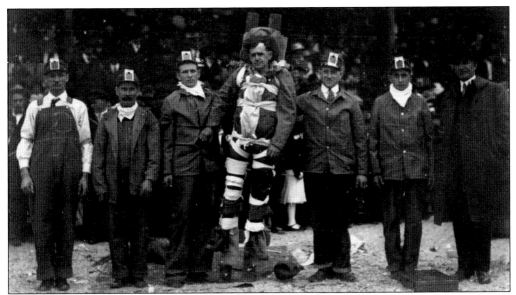

To fuel interest in mine safety training and education, public exhibitions were often arranged for miners to show off their newly learned skills. Accident records for 1916 name the Ideal Mine the winner, where the average time lost by underground employees was a remarkably small 0.023 of one percent, the best in the history of the company at that point.

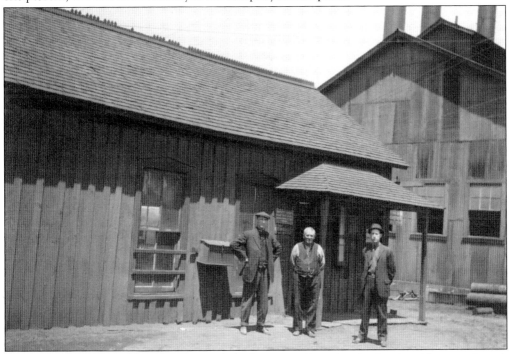

In addition to cash prizes for the camps with the fewest number of work-related accidents, a winner's pennant was displayed at each mine making the highest number of monthly safety improvements. In this photograph, signs posted on a wall outside the office building read "Safety first," "Do not take a chance," "Warn others of any danger," and "Fire extinguisher here," reinforcing safety awareness throughout the camp.

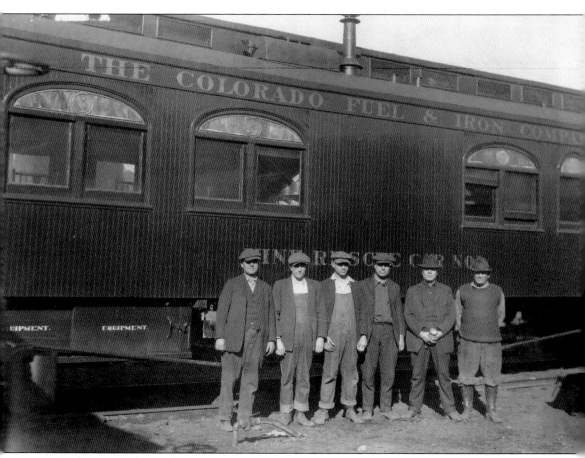

Coal-mining safety and training today is highly regulated, with careful consideration for the safety of workers. In response to several mine accidents, CF&I purchased this mine-rescue car in 1923 and used it as a traveling classroom in all company mining districts, with personnel teaching methods of first aid, job training and certification, dust and methane control, and escape and ventilation procedures.

The superintendent of most of CF&I's mines was the ultimate arbitrator of living conditions. Housing varied in quality and included some 500 three-, four-, and five-room company-constructed houses. The company also allowed miners to rent plots of land to erect their own shelters. In addition, boardinghouses were available to single miners.

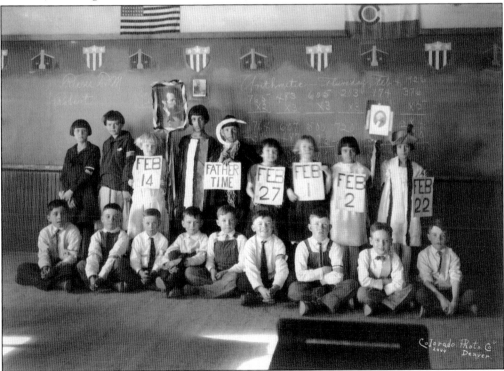

With a growing population, a new schoolhouse was constructed to meet the educational needs of the Cameron camp in the late 1910s. In January 1922, the school caught fire, and the sparks ignited the old schoolhouse located next door, resulting in the destruction of both. After closing for one day, classes resumed in the YMCA, and the school reopened the next year.

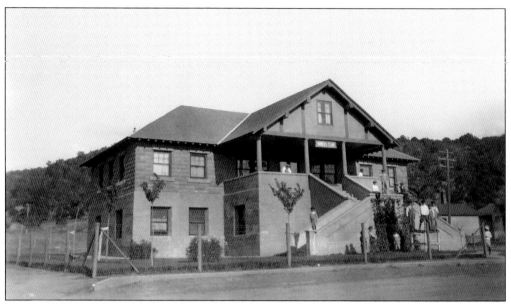

To avoid the further spread of the deadly Spanish influenza outbreak in the autumn of 1918, CF&I enacted strict quarantines and curfews. For those mining camps without a dispensary, such as Ideal, the YMCA clubhouse was turned into a makeshift hospital and was equipped with clean cots and necessary supplies donated by the residents. Employees' wives substituted as nurses, cooks, and dieticians.

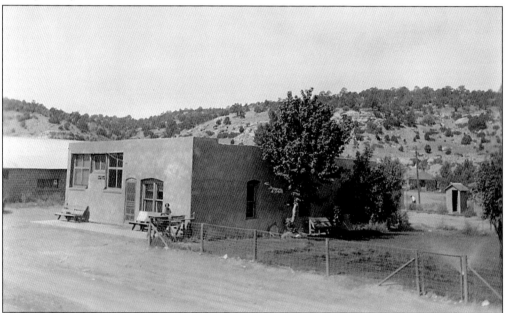

William Dow maintained African Americans were entitled to the same rights as Caucasian employees under CF&I's Employee Representation Plan. He further argued that inside the mine and at district conferences, employees sit together, eat together, talk together, and work together with no discrimination. In April 1919, an agreement was reached allowing African Americans to attend events at the larger Rouse YMCA on the condition that they voluntarily segregate themselves inside the building.

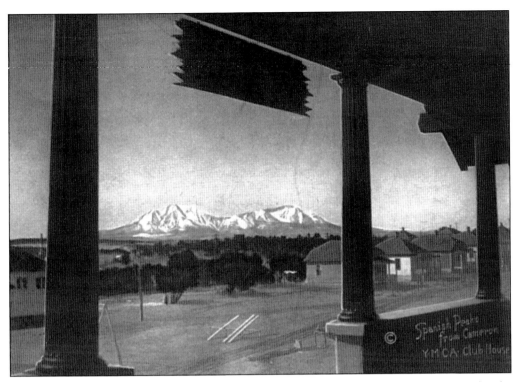

The YMCA clubhouse opened at Cameron in February 1918. Festivities included speeches by company dignitaries, musical entertainment provided by the Cameron Male Quartette, and piano and voice selections by Cameron residents. The evening was completed with a dance in the assembly room of the new club building. A view of the Spanish Peaks mountain range could be seen from the front porch of the YMCA.

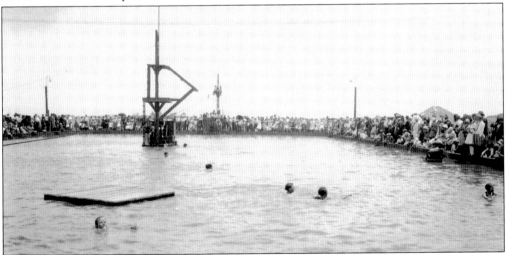

Not found in other CF&I camps, perhaps the most popular feature of Cameron in the summer months was its swimming pool, a reservoir on the nearby Globe Ranch. In the late 1920s, a diving board and slide were added along with swimming lessons. When not used for the swimming pool, water in the reservoir was used to irrigate several acres of pastureland for the Cameron mule team.

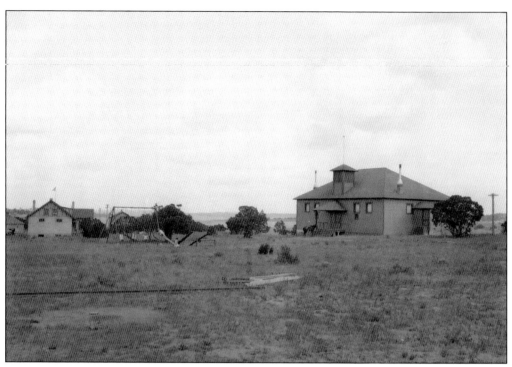

The entire landscape provided a playground for these children at the Ideal School, located at the edge of the Great Plains, with the formidable Rocky Mountains to the west. Daily life for the children of mining families could be both a secluded and a wonderful experience.

Manufacturing entertainment could be as important as mining coal for the lives of coal camp families. Activities included community dances, camp beautification projects, and baseball competitions. This boy, Mickey Patrick, won a camp race.

Six

NORTHERN HUERFANO COUNTY

Between the larger towns of Pueblo and Trinidad in the late 1800s, a settlement and trading post grew up at present-day Walsenburg, due to its proximity to the Cucharas River. The Huerfano County seat was established in 1872 at Walsenburg, and the Denver & Rio Grande Railroad had extended its line down to the area by 1876. The region was rich with large seams of coal that had only been minimally mined because of the lack of export possibilities. With the advent of the rail lines in this part of Colorado, CF&I's predecessor and other companies began to invest in larger coal-mining operations. CF&I eventually built Colorado Supply Company stores, schools, and other amenities for its mining camps. Not every camp had its own store or schools because of the proximity of the camps.

Mines in this area worked different entry points to many common seams, thereby placing them in proximity. Mining entry points for CF&I were created or purchased at Walsen, Robinson no. 1 to no. 3, Kebler no. 1, Kebler no. 2, Jobal, and Pictou. After railroad access was established, the Walsen Mine was the earliest mine to open and begin operation in 1878. With the opening of a few other mines very near Walsen, the grouping was called the Walsen-Robinson Complex. Kebler no. 2, later called Big Four Mine, was operated the longest under CF&I in northern Huerfano County. It remained open until 1953.

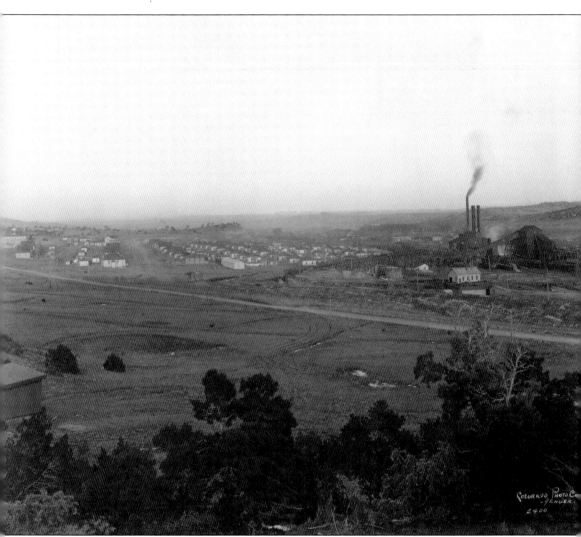

This view of the Walsen camp shows a large portion of the town and mine buildings. The coal washery is at the far right, with the Trinidad Electric Railway Power Plant building to the left of it. The manway entrance to the mine can be seen at the far end of the tracks leading out of the washery. The small white building in front of the washery and tracks was one of two blacksmith shops constructed at the mining camp. At the left of the image, a portion of the town and rows of houses can be seen behind the mine buildings and equipment. At one end of a row are two school buildings, and at the opposite end is a boardinghouse for single men. The only structure seen in this image that still stands today is the power plant building, because it was used after the mining camp was closed in 1931.

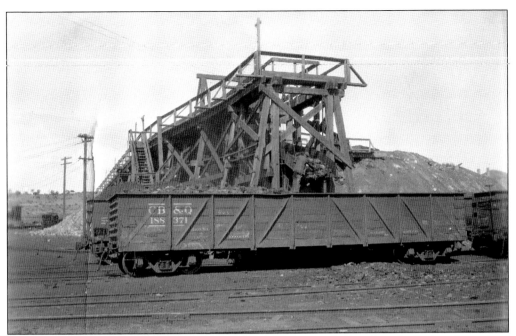

Jobal Mine was located on the Loma branch of the Denver & Rio Grande Railroad, north of Walsenburg. Seen here, a miner is loading lump from the tipple into a Chicago, Burlington & Quincy (CB&Q) Railroad car. Coal lump from Jobal would have most likely been distributed to either domestic or industrial consumers because the quality of coal was not useful for the Pueblo Plant operations.

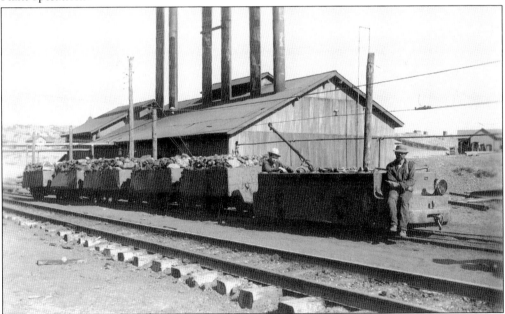

The Jobal Mine was operated by CF&I from 1920 to 1924 and produced nearly 115,000 tons of coal for the company. A company town also existed at the location during that period but was closed once the mine ceased operation. These miners are seated on a trolley locomotive pulling coal cars in front of the boiler house.

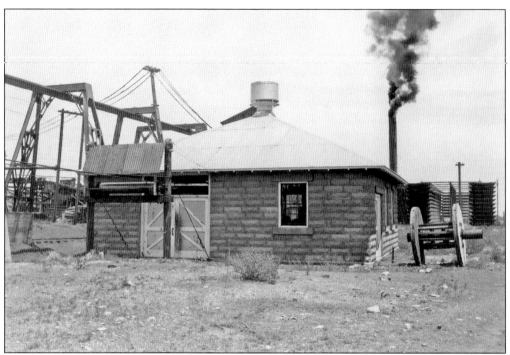

The hoist house at the Robinson Mine housed the machinery that was used to pull coal in skip cars out of the mine. After lumps were extracted from the coal seams by hand mining, they were loaded into one- or two-ton coal cars. These cars were then hauled by a team of mules to the main partings. From there, the hoists pulled the carts the remainder of the way to the exterior of the mine. Coal was delivered to the tipple on average 35 times per day. One of the hoist wheels used at Robinson and seen here was a drum hoist that was powered hydraulically.

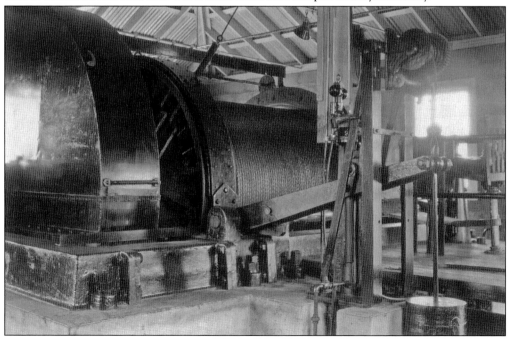

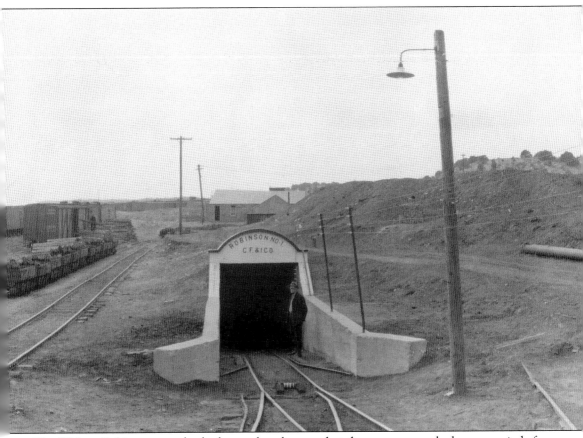

The Walsen-Robinson complex had several coal seams that the company worked over a period of many years. These included the Walsen (Old Walsen), Robinson, Robinson no. 2, New Walsen, and Loma and Breen. The Robinson seam was accessed by the manway shown here. The workers entered the tunnel at this opening to extract coal from a horizontal seam. The seam was opened in 1887 by the Colorado Coal and Iron Company (CC&I), a predecessor to CF&I. Before the merger between the CC&I and the Colorado Fuel Company to form CF&I in 1892, only two seams were operating at the Walsen-Robinson complex. Both the Robinson Mine and the Walsen Mine were worked for coal. After the merger to form CF&I, other seams were opened, and new manways were built to access the coal as older ones were being exhausted. The Robinson Seam was eventually closed in 1924.

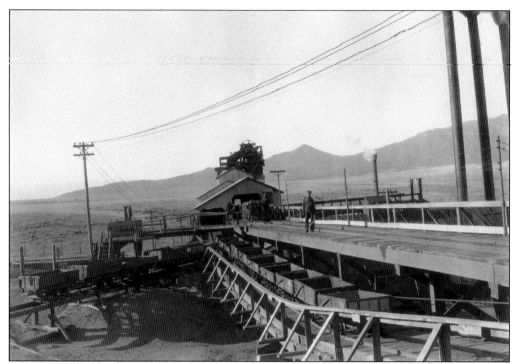

Seen here is the tipple and loaders at Kebler no.1, or Tioga Mine. Many mines were known by several names, usually because of previous ownership. In 1918, Kebler no. 1 was purchased from the Tioga Coal Company. The Colorado Supply Company that served Kebler miners was known as Tioga until it closed in 1953.

The Pictou Mine was located northwest of Walsenburg near the intersection of Redrock Road and Highway 69. The mine was positioned along the Denver & Rio Grande Railroad Loma Branch. The entrance gate to mine building property in this photograph reads "CF&I Co. Pictou." Timber for underground mine room supports can be seen in the foreground.

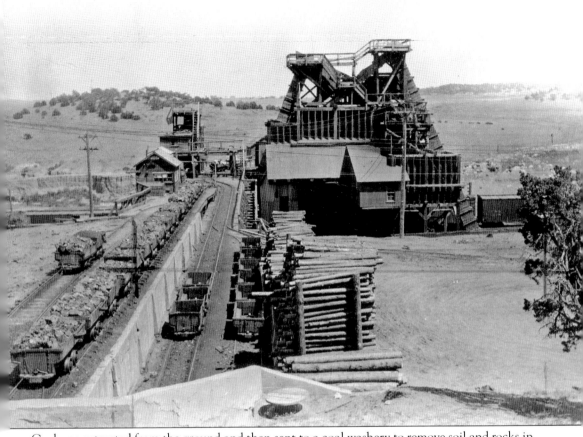

Coal was extracted from the ground and then sent to a coal washery to remove soil and rocks in preparation for sale. This coal washery at Robinson had coal carts bring in loads of lump coal at the top of the washery and send them through a series of screens, where they were then dumped out at the bottom into boxcars. Northern Huerfano County coal seams contained mostly very hard coal. The coal was noncoking in character, which meant that it was not suitable for commercial use in firing blast furnaces for steel production. So, while CF&I was still operating coal mines in Huerfano County, it provided a domestic fuel supply for coal-fired heating of homes and buildings. The majority of the coal mines in this county did not operate past 1940, with the exception of Kebler no. 2, which produced coal until 1953.

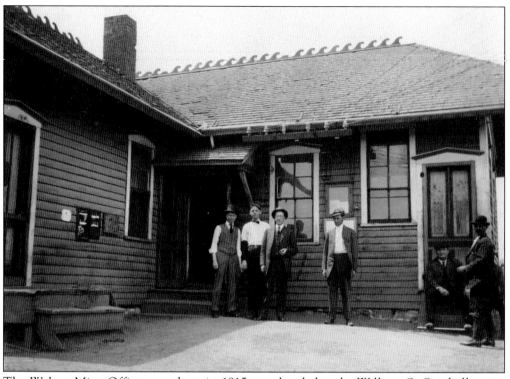

The Walsen Mine Office, seen here in 1915, was headed up by William S. Getchell, mine superintendent. Getchell began his career as superintendent of Morley in 1913. From there, he was transferred the following year to oversee the Walsen-Robinson Complex. He remained in this position until 1925. Getchell was concurrently the mining superintendent for the Pictou (1916–1925) and Jobal (1919–1924) Mines.

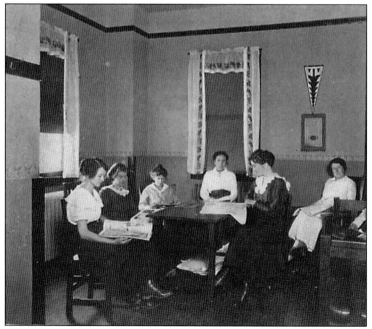

Walsen, like many of the other CF&I company towns, had a YMCA club for employees and their families. Besides recreational activities, the clubs offered a variety of courses and opportunities for socializing. These women are seated and reading in the women's parlor at the Walsen YMCA. To use the club's amenities, they would have been some of the 1,000 paying members throughout the mining camps in 1916.

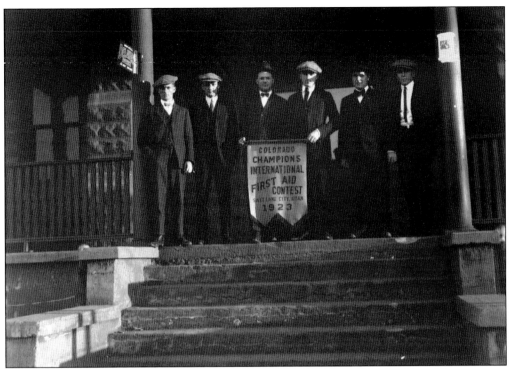

This group of Walsen miners is standing on the steps of the Walsen YMCA building. The men were sent to Salt Lake City for an international first aid contest. In 1939, the Walsen safety team again won a safety competition, which was a fun and important activity for the mine rescue teams.

The Colored YMCA Club building was located at the far end of the Walsen camp. The Colored Club was ideologically and physically separated from the YMCA for white miners and their families. This building was located at one end, while the YMCA was built on the opposite end of the mine buildings. In 1915, when this photograph was taken, segregation was a regular practice throughout the country, and CF&I was no exception.

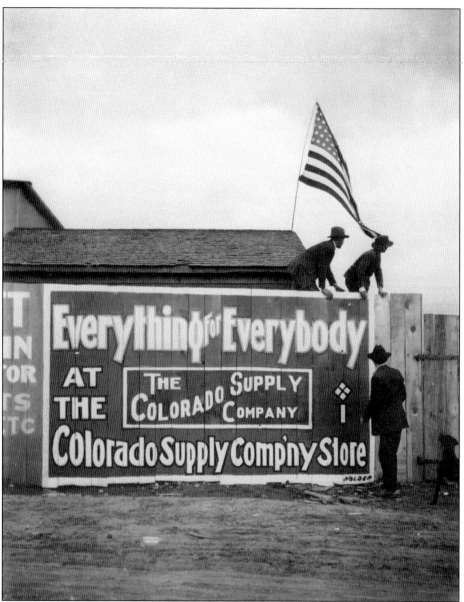

In 1888, the Colorado Supply Company was founded by the Denver Fuel Company and the Colorado Fuel Company, predecessors to CF&I. The charter of the firm allowed for the establishment of a merchandising business. Thus the president, John C. Osgood, and the board of directors created the Colorado Supply Company. After the initial setup in 1888 at the Rouse Mine in Huerfano County, stores were then established in a few other mining towns in Southern Colorado. In 1893, C.M. Shenk began managing the stores and remained in the position for 20 years. He expanded store locations to include mines in Las Animas, Huerfano, Fremont, Garfield, and Pitkin Counties in Colorado, and a few in New Mexico, as the parent company, CF&I, expanded its holdings. Although they began simply as groceries, the stores eventually stocked more merchandise to include dry goods, home goods, clothing, and even alcohol. In 1915, this park fence in Walsen displays the fitting slogan for a company in the height of its operation: "Everything for Everybody."

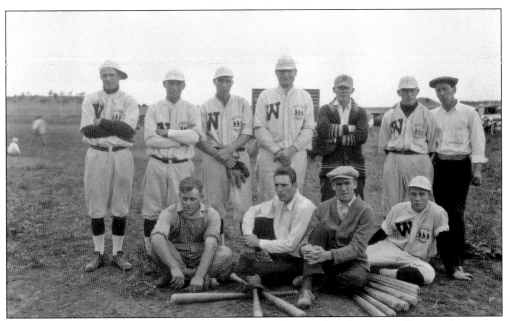

Baseball was greatly enjoyed by miners throughout Southern Colorado, as it was by most Americans in the first part of the 20th century. This 1926 team is composed of Walsen miners who played in CF&I tournaments between other mines and Pueblo mills. The insignia on the left sides of their uniforms is the logo for Diavolo Coal, the CF&I brand of coal for domestic use.

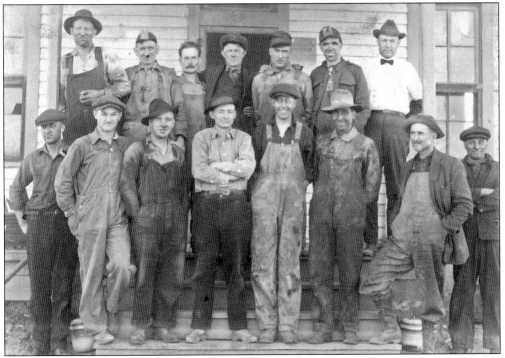

These employees are part of a vocational education class at Pictou on January 15, 1921. Dressed in both casual daily wear and work uniforms, the miners range in age. Some men applied for mine work as young as 16, and others could be as old as 50 when they started.

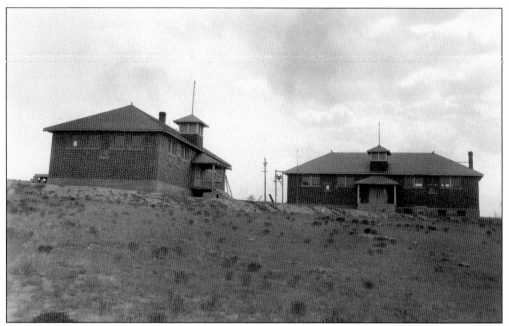

The school buildings at Kebler housed students of mining families. These two buildings had room for eight grades. If a student continued on to high school, he or she would have to attend class in Walsen. Many of the mining camps contained only lower grade schools and sent older students to high schools with children from other camps.

CF&I placed emphasis on the appearances of its mining camps and its Pueblo mills. The company publication, the *Industrial Bulletin*, was published for employees and management and often highlighted the award-winning gardens of homes in the mining camps and encouraged the beautification of CF&I properties. This Kebler home showcases unique star-shaped flower gardens. Its owner, Thomas Nickloff, a Bulgarian immigrant, is sitting on the stoop.

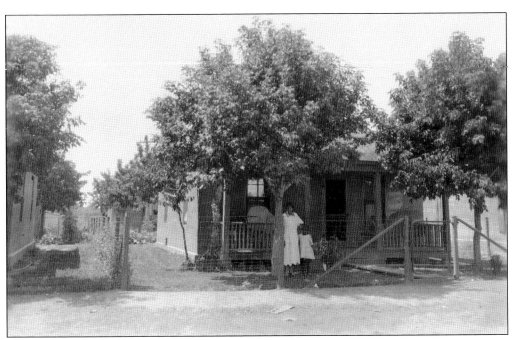

In 1924, CF&I employed 150 African American workers in its mines. Of these, 92 individuals worked in the Huerfano County mines. Willard White, an African American miner at the Walsen-Robinson complex, received a "25 years of service" button in 1916 for his service to the company. He lived in Walsen with his wife, Pearl, and their daughter Laetha. Willard moved his family from Birmingham, Alabama, to Colorado to work for the steel industry, like many migrants from Alabama. Another African American family, pictured here, is seen outside their home at house no. 26 in Robinson. CF&I employed people from many nationalities in the Huerfano County mines, including 316 Mexicans, 22 Hungarians, 11 Germans, 203 Italians, and 1 Bohemian.

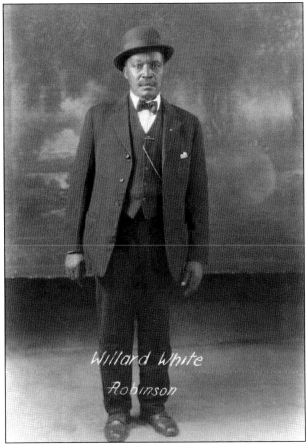

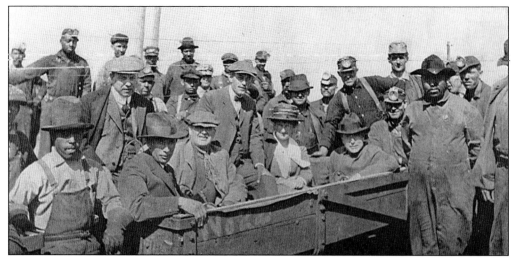

In 1918, John D. Rockefeller Jr. visited the mining and plant properties of CF&I to boost support for the Industrial Representation Plan. At Walsen, Rockefeller entered the mine to see the working conditions. Rockefeller, seen here seated at far right in the coal car, and W.L. MacKenzie King, seated at far front left, accompany Abigail "Abby" Rockefeller for the photo opportunity with mine workers and foremen.

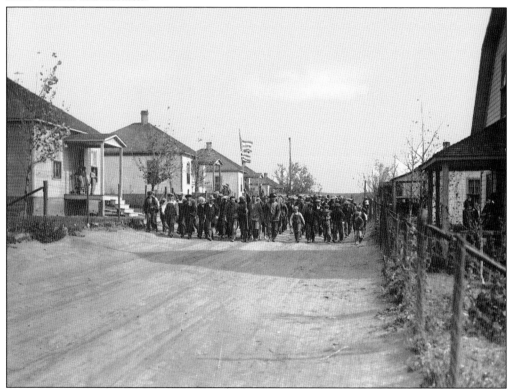

The Colorado Coal Strike in the 1920s was called by the Industrial Workers of the World and affected nearly 4,000 miners and their families. Shown here are strikers and sympathizers marching through the streets of the Walsen camp on November 3, 1927. This photograph was taken by Wide World Photos, the photograph agency of the *New York Times*.

Seven

Fremont County

Fremont County is located in Southern Colorado, west of Pueblo. Coal mines owned and operated by CF&I included Fremont, Nonac, Rockvale, Brookside, Coal Creek nos. 1–3, Nushaft, Chandler, and Emerald. All of the mines in the Canon District provided coal for the company's fuel operations and sales. CF&I prospected in the county for other minerals, including limestone, ganister, fluorspar, calcite, iron ore, manganese, and fireclay, but never found many viable sources.

All of the mines in Fremont County were in the southeast corner, in the foothills of the Wet Mountains, and several of the mines were located along the same large seam. The coal from the area was classified as low-grade bituminous. Due to its quality and the size of breakage, it was sold for commercial and domestic uses. Thanks to its holdings of all of the producing coal mines in the Canon District, CF&I had a monopoly in the market for this fuel that was popular in Colorado and adjacent states.

The Coal Creek Mine was purchased by CF&I after the predecessor company had successfully begun large-scale mining along the coal seam. In 1896, CF&I bought out the only other competition in the area when it leased the Brookside and Rockvale Mines. The company established towns at Coal Creek (1872–1931), Chandler (1895–1896), Rockvale (1896–1927), Brookside (1896–1910), Fremont (1896–1927), Nonac (1904–1952), and Emerald (1919–1925). By 1952, the last company town and mine closed at Nonac, also known as Rockvale no. 5.

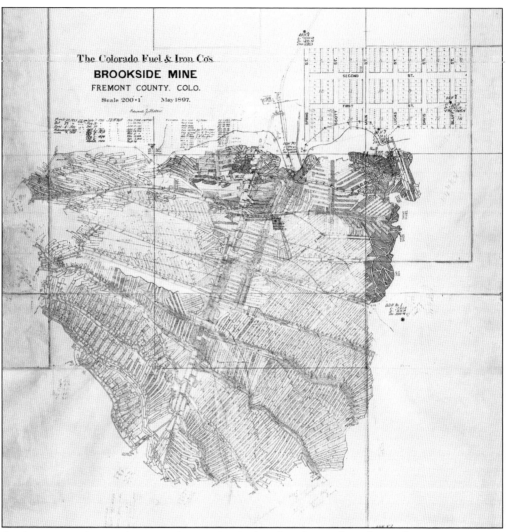

The Colorado Fuel & Iron Co's
BROOKSIDE MINE
FREMONT COUNTY. COLO.
Scale 200·1 May 1897.

An important element in managing a mine is the planning and tracking of progress as mines are extended. This duty fell to the mining engineers, who surveyed the workings underground to ensure progress was made in the right direction. Until 1910, a division engineer office was located in Canon City to survey all of the Fremont County mines. The engineer's office was later expanded to include tracking progress of mines in Gunnison County. By 1930, because of advancements in transportation, all mine engineering was done from the Pueblo headquarters. This map of the Brookside Mine was extended, or had additions drawn, 50 times from its original creation in 1897 until the extension of 1929. The mine had ceased production in 1910, but the map was updated until 1929. Along with the underground workings, coal outcroppings, and buildings, the town of Brookside is also visible. Brookside was located to the southeast of Canon City. Blocks seen in this drawing still exist today.

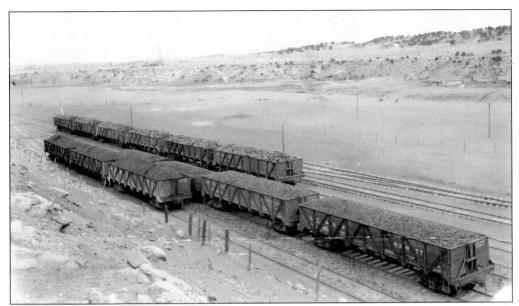

Several railcars of the Atchinson, Topeka & Santa Fe (AT&SF) Railway are shown filled with low-grade bituminous coal from the Nonac Mine. Most of CF&I's mines in the Canon District of Fremont County were located along the main or branch rail lines of the AT&SF. The only exception was the Fremont Mine, which was located on a branch of the Denver & Rio Grande Railroad (D&RG).

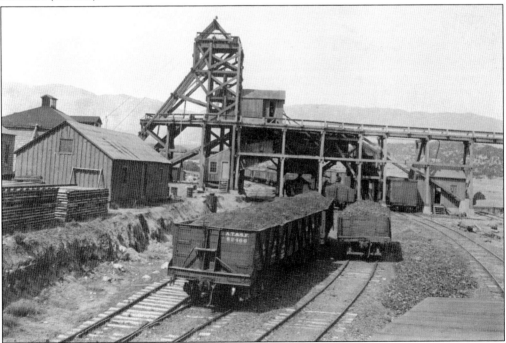

The Coal Creek Mine was accessed by a sloping entry. All mining was done by hand because of the location of the coal in the ground. The 412-foot shaft was sunk in 1912, and the mine was fully electrified. The electric hoist brought coal up to the tipple, where it was then loaded into railcars for shipment.

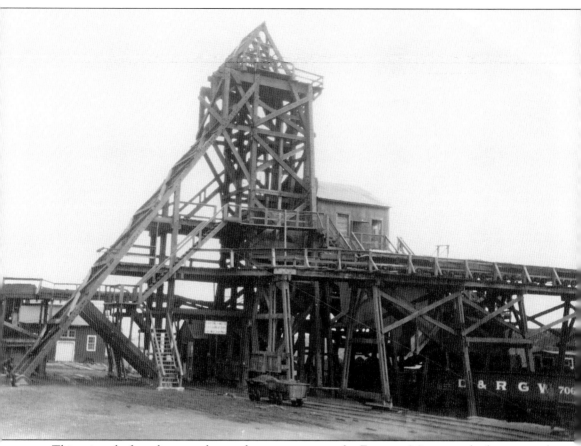

This mine shaft and some other surface structures at the Fremont Mine were built as second-generation facilities after a fire destroyed parts of Fremont's operations in 1905. According to production records, coal was still mined during this time and continued to be extracted until the mine's closure in 1927. The Fremont Mine was known locally as Bear Gulch. It was sold to CF&I in 1894, only two years after it was opened by the United Mine Coal Company. CF&I did not start coal production at the site until 1896. Nearly all of the coal extracted was sold for commercial and domestic consumption, while the remaining 10 percent was utilized by the company in operations such as coal-fired engines for cooling and ventilation in the mines. Over the life of the mine, nearly 2.6 million tons of coal were produced.

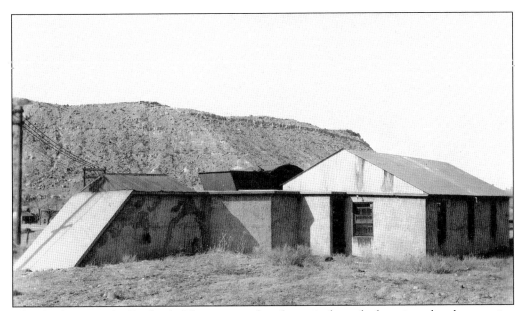

This fan house at the Rockvale Mine was used to draw air through the mine, thereby ensuring that the stagnant air underground did not fill with coal dust as miners worked. Mining also posed the threat of dangerous gases, which the fan house was designed to limit. The fan was originally coal-fired, but eventually, it was converted to electricity.

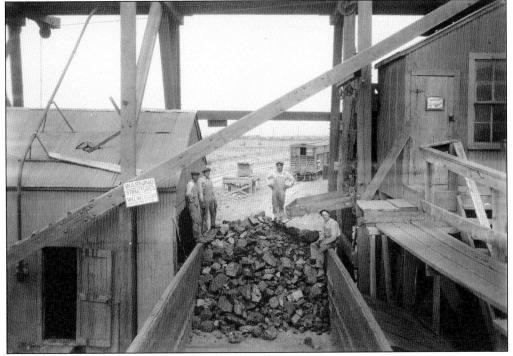

Coal Creek was the earliest of the CF&I mines in Fremont County. It provided over five million tons of coal between 1872 and 1931, when it was closed. It had several different entry points and was, at different times, named Rockvale no. 2, Rockvale no. 3 and Nushaft. The workers in this photograph are sitting atop a car filled with coal sold for domestic uses.

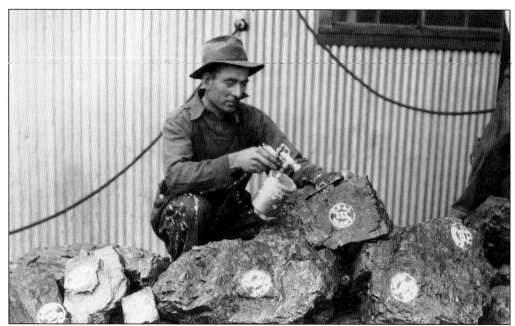

The sale of coal was a major portion of the company's income during its earlier history. Diavolo Coal was the trademark CF&I used for marketing its coal for domestic and commercial fuel. In 1926, CF&I touted that "it takes about 150,000 40-ton railroad cars to transport one year's production of Diavolo Coals to market." The signature three devils were used in the merchandising and sales departments. As part of the marketing effort, the company, for a time, used trademark tags to increase visibility of the product while in transit. Individual pieces of coal were also sprayed with the logo. Seen in the above photograph is the Diavolo logo for "Giant" lumps of coal. Rockvale was known for large-sized coal, which was desirable in the market.

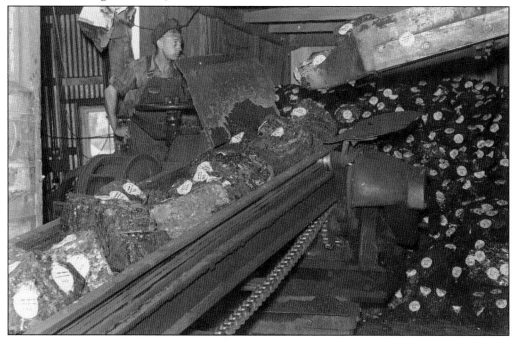

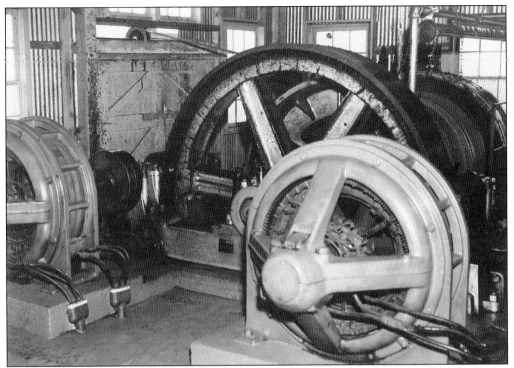

Nonac, or Rockvale no. 5, used a hoist to lift coal into railcars for transportation, after being broken into lumps or sifted into smaller pieces. The machinery, seen here in 1942, was electric at this time. Nonac, which derived its name from the spelling of Canon backward, was the last Canon District mine in operation in 1942.

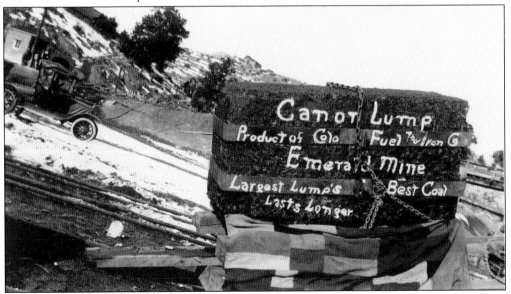

The Emerald Mine was purchased by CF&I on December 1, 1919. The coal mine produced 171,678 tons of coal before this date. CF&I extracted approximately 1,200 tons per month before closing the mine in 1925. Emerald was located about 1.5 miles west of Florence, Colorado, which meant that there was really no need for a company town or store on the property.

The stables at Rockvale Mine housed the mules used by miners to transport carts along tracks inside the mine and to haul coal out of mines. Mule power was used until technological advancements replaced the need for animals. The stable building was located along the side of Oak Creek, which ran through the mining camp, as shown on this map. Above Oak Creek, the mine-working buildings are also visible, including the lump car loader over the railroad tracks, the bath and lamp house, the blacksmith shop, and the hoist house. The residential blocks in Rockvale, shown here in 1919, are still laid out in a similar manner.

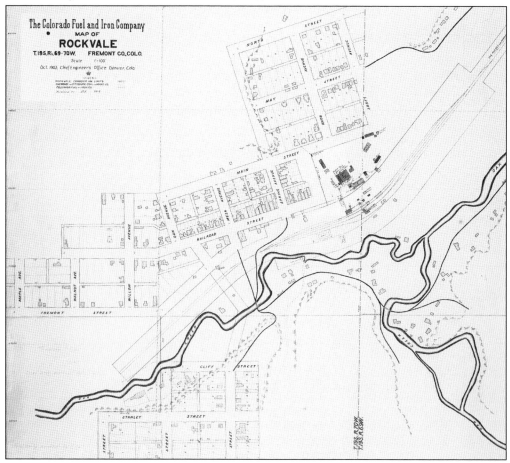

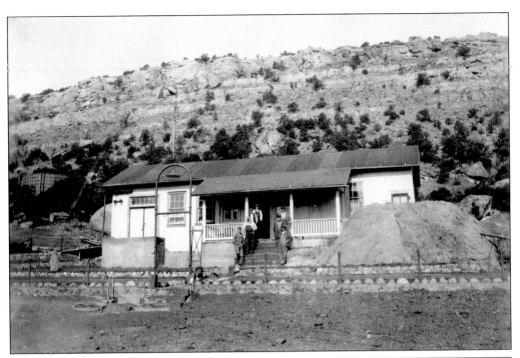

The Canon District mines were located at the foot of the Wet Mountains, a small range with relatively low elevation in comparison to the nearby Sangre de Cristo Mountains. The region lies in a high desert. This image of seven miners standing on the steps of the Fremont County Mining Office includes a view of the dry area and low shrubbery typical of the Canon District foothills.

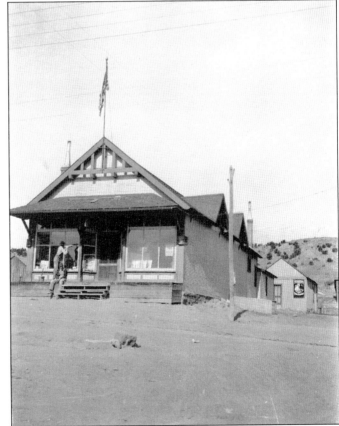

The Coal Creek Mine was purchased in 1872 by the Central Colorado Improvement Company, a predecessor to the Colorado Fuel and Iron Company. It was one of the first domestic mines owned and operated by CF&I. The company store was established by 1897 to serve the miners of Coal Creek.

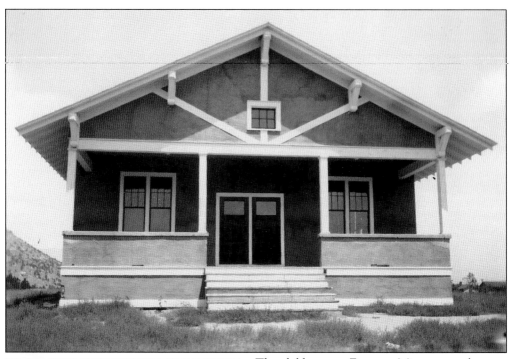

The clubhouse at Fremont Mine, erected in 1920, was part of the Sociological Department's efforts to improve the welfare of the company employees. The YMCA provided mining families with recreation and entertainment. The building was later used as the women's club for miners' wives.

The home of miner Thomas Blythe won first prize for lawns and gardens in the Fremont mining camp in 1923. The woman in this photograph, probably Blythe's wife, stands at the front of the home showing off the prizewinning yard. This was not the first time the home won the prize. In 1916, Thomas Blythe's home also won the lawn and garden contest.

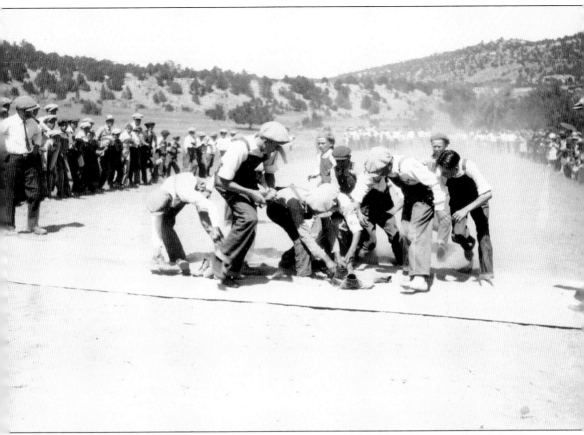

The CF&I mining camps hosted many community picnics and field days. Miners and their families took part in various competitions, including "shoe races." Individuals would throw their shoes into a mixed pile and race to see who could pull on a matching pair the quickest. These boys were probably the children of miners in the town of Rockvale. This picnic, on August 18, 1926, included the shoe race, a centipede race, a burro race, broad jump, a women's baseball game, and a women's nail-driving contest. Company picnics also included the popular and practical first aid competition. Miners from Rockvale competed in the 1920 Fuel Department Field Day in Trinidad, which included teams from Las Animas, Huerfano, and Fremont Counties.

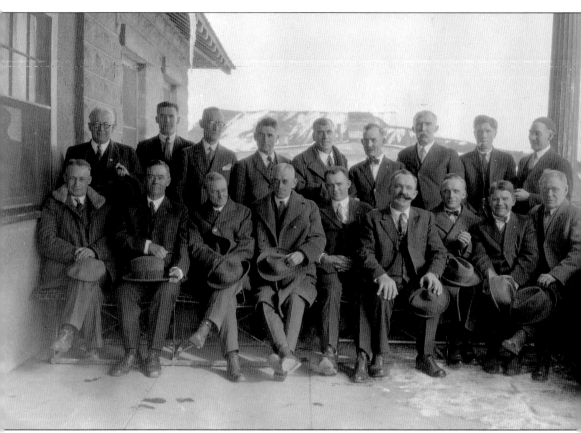

The Joint Committee for the Canon District was held at Rockvale in January 1926. The committee included the 18 individuals pictured and integrated both management and miners representing individual mines. Edmond Kitto is pictured in this group (see page 110), as is J.D. Cribbs, the superintendent of Rockvale Mine in 1926. Committees of these individuals were formed to discuss and address issues in the areas of cooperation, conciliation and wages, safety and accidents, sanitation, health and housing, and education and recreation. Reports were then given in December at the Fuel Department Annual Meeting. The Joint Representation Plan was adopted in 1915 by coal mines, and was extended to steel works, iron mines, and lime quarries in 1916. According to Jesse Welborn, president of Colorado Fuel and Iron Company at the time, the "object was to develop better understandings between management and employees."

The coal camps of Southern Colorado drew many immigrants to the area, and Fremont County mines were no exception. According to the nationality numbers, recorded by the company in 1923, there were 258 Italian workers, 199 classified as American, 48 Austrians, 20 Welch, 18 Mexican, and 1 Chinese, among the 643 total employed in Fremont County mines. Italians dominated the Canon District at the time and had a high population in the other CF&I mining districts in Southern Colorado. Geo (also recorded as "Joe") Berta was an Italian immigrant who began work in the CF&I Mines in 1895. He was born in 1875 and married a woman named Anna, who was also from Italy. They had one daughter, Theresa, born in 1915. In 1920, Geo was awarded a 25-year pin for his service in Rockvale. While employed by CF&I, he worked in the Rockvale Mine continuously from 1910 until 1927, with the exception of strikes. He participated in strikes in 1921 and 1922. In the 1940 Census, at the age of 64, he is listed as a farmer of garden produce in the town of Rockvale.

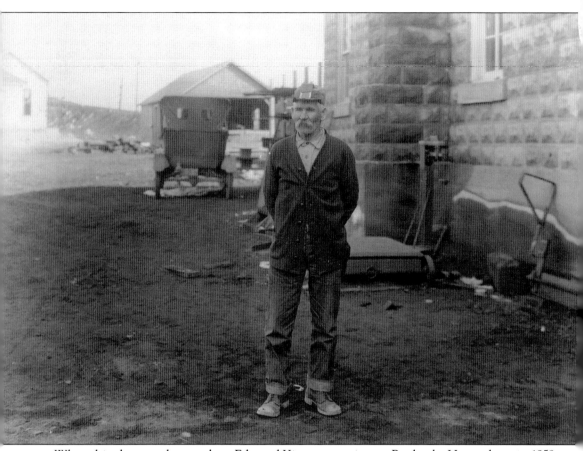

When this photograph was taken, Edmund Kitto was a miner at Rockvale. He was born in 1859 in Canada (or possibly England) but lived and worked as a miner in Iowa as a young man. In 1881, he married Mary, a woman who immigrated to the United States from Scotland as a child. The young couple moved to Colorado from Iowa sometime in the mid-1880s, in search of work to feed their growing family, which would eventually total at least six children. In 1924 and 1925, after decades of employment with the company, Kitto served as an official CF&I employee representative as part of John D. Rockefeller Jr.'s Employee Representation Plan. As an employee representative, he was responsible for meeting with company officials to discuss the grievances of his fellow miners. Additionally, he served on the Canon District's Safety and Accident Committee, which entailed working with other employee representatives to conduct inspections of the mines and to write reports informing management of safety problems. Kitto retired in 1926 after 39 years of employment with CF&I.

Eight

THE END OF AN ERA

A number of factors led to the decline of CF&I's coal-mining operations through the first half of the 20th century. The decline of the smelting industry, along with a reduced demand for coke, led to a diminished demand for coal. Coal production peaked in 1912, then declined until World War I provided new markets and output again soared. The Great Depression devastated the coal market, then competition from new forms of fuel, such as petroleum and natural gas, led to the eventual demise of the industry.

From 1922 to 1930, CF&I closed 13 mines, including Starkville, Engleville, Sopris, Berwind, Tobasco, Primero, Jobal, Lester, and Kebler no. 1. Toller, Ideal, and Walsen fell victim to the Great Depression. A few mines prospered during World War II, but Nonac, Kebler no. 2, and Pictou closed between 1946 and 1952. Morley ended operations in 1956 and Frederick closed in 1960. The Allen Mine opened in 1951, and is the sole CF&I mine that still has modern production potential. Equipment and resources that could be scavenged from the mining towns were quickly removed. Today, the remains of most of the towns consist of abandoned foundations.

In the spring of 2012, the authors embarked on a project to document the remains of the CF&I company towns. With maps and other archival documentation, they traveled the Colorado Highway of Legends Scenic Byway, which follows a route near many of the former towns. This final chapter offers images of past and present to show what remains, along with images of what was once there. The intent is to encourage others to experience the history of CF&I in a similar way. However, for anybody interested in following in these footsteps, please be aware that many of the sites are now on private property and should not be entered without permission from the owners.

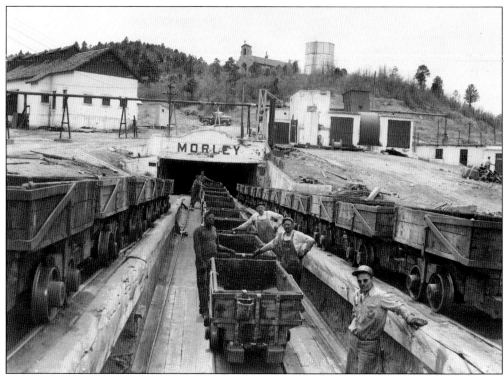

In the photograph above, workers pose with empty coal cars at the entrance to the Morley Mine in Las Animas County on its last day of operations in 1956. Through its 49-year history, the mine produced over 11 million tons of coal. In the photograph below, a car drives down a residential street in Morley, with St. Aloysius Catholic Church on the hill in the background. Religion was an important aspect of life in the camps, partially due to the encouragement of company officials. Owner John D. Rockefeller Jr. made personal donations for the construction of churches in numerous mining towns, including a donation to build St. Aloysius.

These two modern views show St. Aloysius Catholic Church as a point of reference. Gone are the homes, the company store, the clubhouses, and the mine structures. All that remains are a skeletal church steeple and a few stone foundations. The Morley site now rests just a short distance west of Interstate 25, and the church steeple is visible from the highway. (Both, Tim Hawkins.)

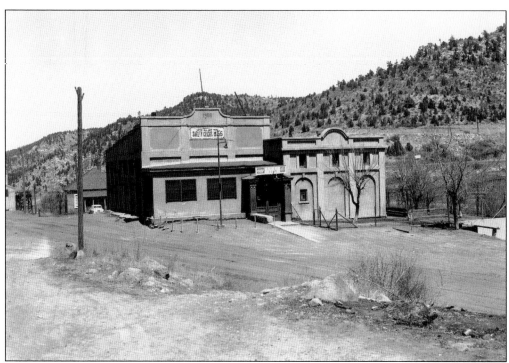

As discussed in previous chapters, CF&I funded the construction of YMCA buildings in many company towns to serve the recreational needs of coal miners and their families. Shown here are two views of the Morley YMCA, built in 1908. In the image above, it is clearly visible that the building was called the CF&I Club. Although the view below would appear to be a modernization of the same building, the automobiles in the photographs would suggest the opposite.

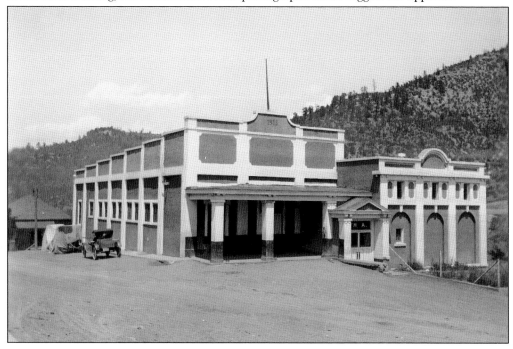

Positively identifying the remains of the former CF&I structures is not necessarily a precise science. From town maps, along with on site evaluations of the exact locations of the remains, and with close inspection of historic photographs, this foundation appears to be the Morley YMCA. (Tim Hawkins.)

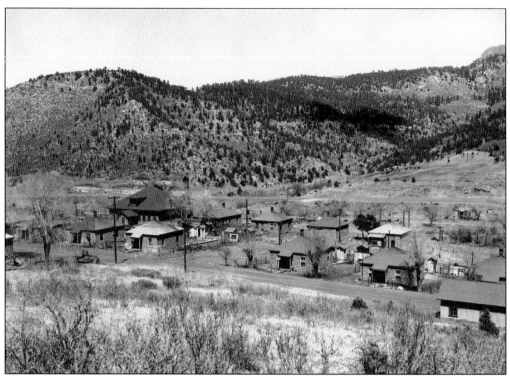

These two views show the general layout of the company homes at Morley. Typical of the CF&I miner's house is the square design with the chimney in the middle. The views also illustrate the common siting of many CF&I company towns in Southern Colorado, being situated either in canyons or valleys.

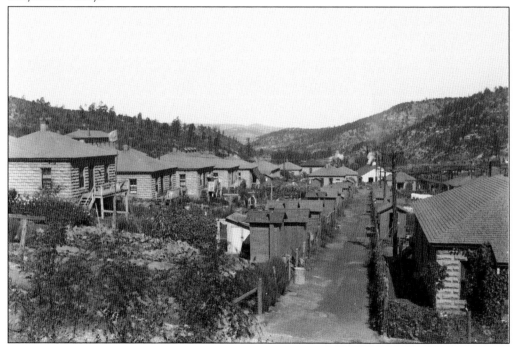

Although not shown from the exact locations as the facing images of Morley, these modern views illustrate how little may be left in former mining camps. Now looking typical of a Southern Colorado outdoor scene, only the ghostly square of rocks indicates that at one time this place was inhabited, yet this was once the center of Morley. In the other scene, Interstate 25 is visible in the distance. (Both, Tim Hawkins.)

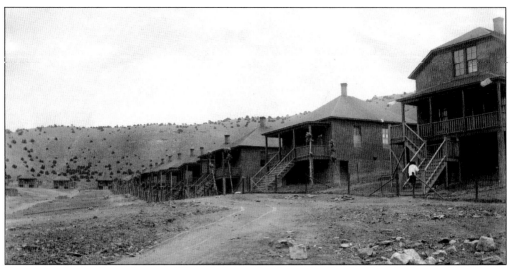

Sopris was located southwest of Trinidad, not far from the Starkville, Morley, and Frederick Mines. The town was in existence from 1888 to 1928, although the mine did not operate as a CF&I mine until 1911. When the mine shut down in 1940, it had produced almost nine million tons of coal.

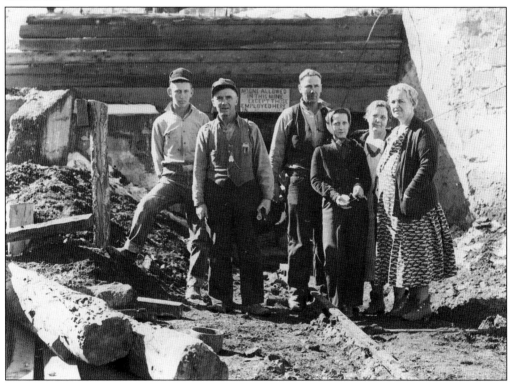

The Deldosso family stands outside at the close of the Sopris Mine. This photograph appears in a *CF&I Blast* article that states, "Shortly before the final blast that closed the old Sopris mine, the Deldosso family, operators of the mine, posed for this picture in front of the mine's mouth. Left to right are Jack Deldosso Jr., Jack Deldosso Sr., Tom Deldosso, Dorothy Deldosso, Mrs. Tom Deldosso and Mrs. Jack Deldosso."

As an extreme example of the loss of historic places, Sopris now sits at the bottom of Trinidad Lake. In 1970, the Army Corps of Engineers finished a dam designed to save Trinidad from periodic rampages of the Purgatoire River, flooding the former site of Sopris in the process. Now Trinidad State Park, it is described by Colorado Parks and Wildlife as "a beautiful setting in the mountains of Southern Colorado, with a mild year-round climate and 800 acres of water ideal for numerous water sports. Anglers catch rainbow and cutthroat trout, largemouth bass, channel catfish, walleye, crappie and perch. The lake is popular for water skiing and windsurfing." (Both, Tim Hawkins.)

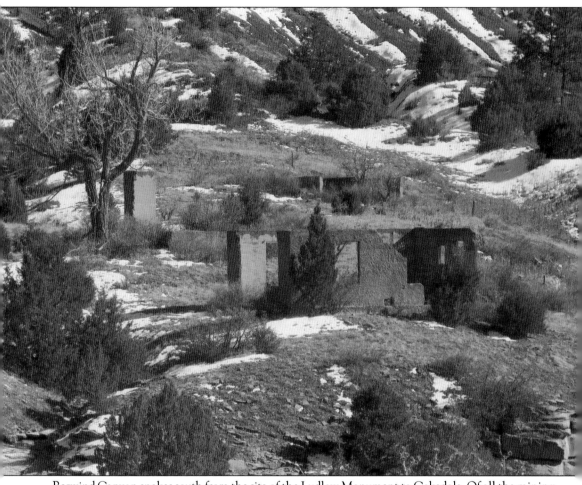

Berwind Canyon snakes south from the site of the Ludlow Monument to Cokedale. Of all the mining sites in Southern Colorado, Berwind Canyon has some of the most intact remains, many clearly visible from the road. Shown here is an unidentified foundation with some of the walls still standing. Chapter 4 is an in-depth look at the mining towns of Berwind Canyon. (Tim Hawkins.)

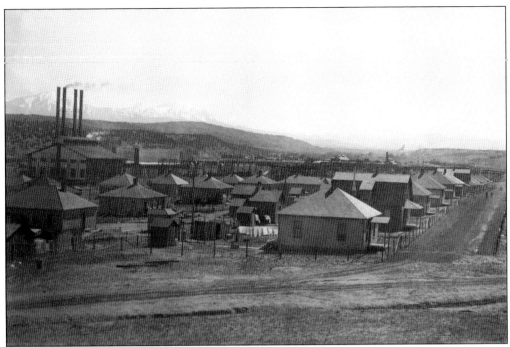

In the late 1800s, the production of steam coal was centered in the Walsenburg District. The first mine opened in 1886. Originally named Cucharas, it was later renamed Walsen. Shown here is the town; the power plant is clearly visible in front of the 13,000-foot Spanish Peaks.

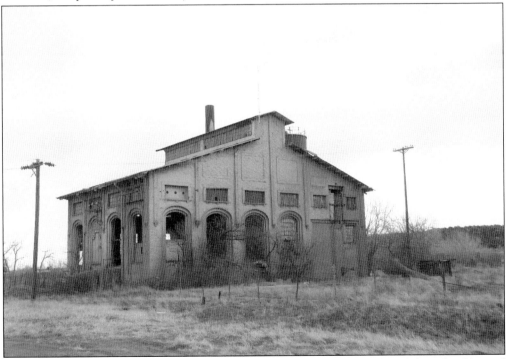

At the former Walsen site now sit the skeletal remains of the power plant. Although fenced and located on private property, the structure is large and easily viewed from the roadside. (Tim Hawkins.)

This row of houses at Primero sits very close to the former main street. Using the Primero town map shown on page 32, along with ledger books that were used to record transactions such as rent payments or purchases at the company store, it is possible to draw quite a vivid picture of the lives of the Primero miners and their families.

The superintendent's house at Primero, as was typical of superintendent homes in most company towns, was larger and more lavish than most residences. In addition, as is also typical, the Primero house was physically separated from others, in this case sitting on a scenic Primero hillside. When this photograph was taken in 1915, the residence was occupied by Joe Haske and his family.

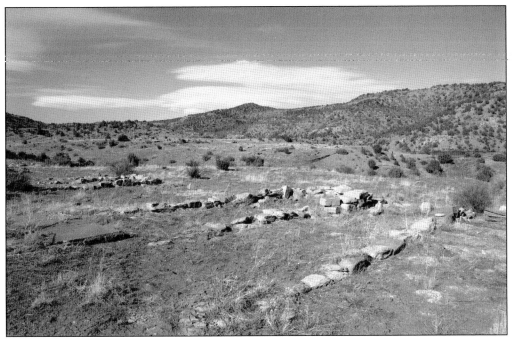

Gone are the homes, but the main street remains at Primero. These former foundations line a dirt road that still runs a course from the former site of the Catholic church and ends at the Protestant church. With the structures gone, it is easy to imagine why the Southern Colorado company towns had a need for self-sufficiency. (Tim Hawkins.)

Again, referring to the Primero town map, along with a positive identification of the stone steps leading into the medical dispensary, just downhill from this site, it is reasonably certain that this cube of rocks is the remains of the superintendent's home. (Tim Hawkins.)

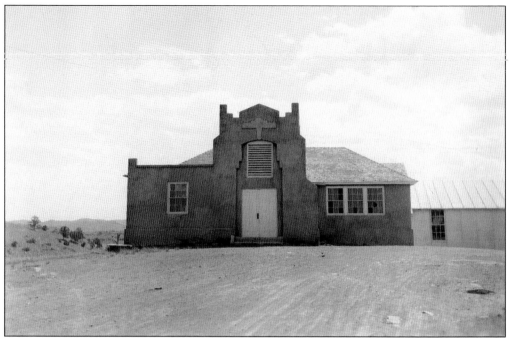

Primero supported two churches, one Catholic and one Protestant. They are clearly indicated on the Primero town map at opposite ends of the main street. The Catholic church can be easily spotted in a number of the photographs shown in chapter 2. This is a view of the Protestant church.

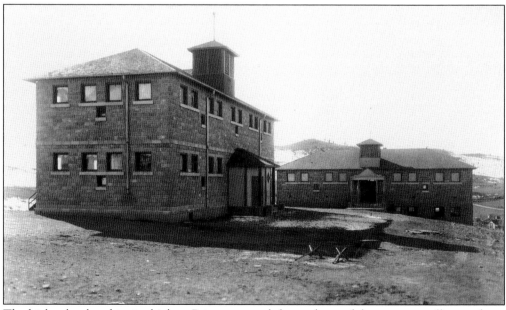

The high school and junior high at Primero served the students of the town as well as students arriving from Segundo and Valdez on the "school train." Schools were also used as community centers before the YMCA camp clubs were constructed.

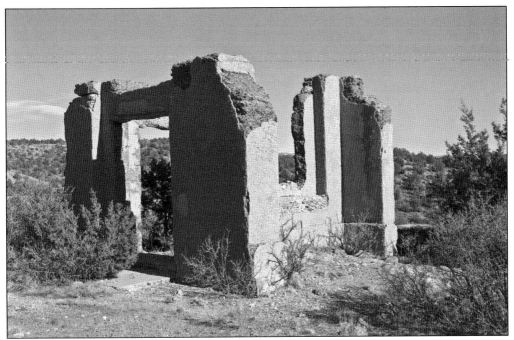

Clearly identifiable from the Primero town plat, along with comparisons to historic photographs such as the one shown on the facing page, these walls and foundations are all that remains of the Protestant church. (Tim Hawkins.)

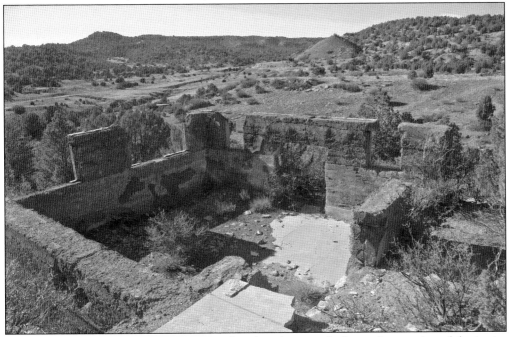

Also identifiable from the Primero town plat, this photograph shows the remains of the junior high school, the structure on the right in the photograph on the facing page. Visible in the background is a pyramidal mound of mine tailings next to the canyon leading to the former mine entrance. (Tim Hawkins.)

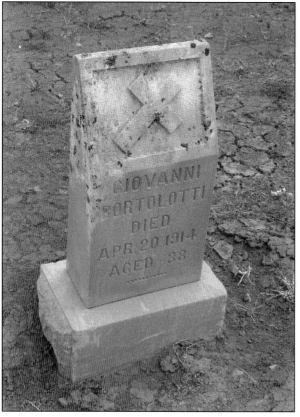

The Catholic cemetery in Trinidad is the final resting place for many of the miners who perished in the Southern Colorado coalfields. Among the oldest headstones may be found remains of multiple burials, some for miners who died together in tragic underground explosions. Buried here also are a few of the victims from the Ludlow Massacre in 1914. The cemetery provides a hallowed scene to honor and remember the lives of the men and women who toiled to build the industrial West. (Both, Tim Hawkins.)

ABOUT THE BESSEMER HISTORICAL SOCIETY

In 2000, the Bessemer Historical Society (BHS) was formed as a nonprofit organization by a group of Pueblo's concerned citizens. Its mission is to provide continuing education to the public through the preservation of the historic archives, artifacts, and buildings of the Colorado Fuel and Iron Company (CF&I). BHS collects, preserves, interprets, and exhibits the collections of the steel and mining industry, the Bessemer neighborhood, and the working families of the steel and mining industry in the region and the industrial West.

Corporate records, films, photographs, artifacts, maps, and drawings from the CF&I collection are housed in the historic main office building of the Colorado Fuel and Iron Company. This vast collection offers a wealth of information relating to labor history, history of industry, mining, land and water resources, railroads, and corporate history. The collection also includes records of general historical interest and of personal employee history. It traces the history of the huge enterprise that was CF&I, which in turn, is the history of Southern Colorado.

With generous funding from the National Endowment for the Humanities and many others, the Bessemer Historical Society is preserving these records, making them accessible to researchers, and interpreting them in exhibits at the Steelworks Museum. When completed, this archives will be one of a handful of such collections in the United States.

Future plans include an expanded museum and a state-of-the-art archives research center to serve scholars, students, family historians, and lifelong learners. To learn more about the Steelworks Museum, or for online access to selections from the CF&I Archives, please visit our website at www.steelworks.us.

DISCOVER THOUSANDS OF LOCAL HISTORY BOOKS FEATURING MILLIONS OF VINTAGE IMAGES

Arcadia Publishing, the leading local history publisher in the United States, is committed to making history accessible and meaningful through publishing books that celebrate and preserve the heritage of America's people and places.

Find more books like this at
www.arcadiapublishing.com

Search for your hometown history, your old stomping grounds, and even your favorite sports team.

Consistent with our mission to preserve history on a local level, this book was printed in South Carolina on American-made paper and manufactured entirely in the United States. Products carrying the accredited Forest Stewardship Council (FSC) label are printed on 100 percent FSC-certified paper.

MADE IN THE USA